Creating
Logo
Families

Edited by
David E. Carter

Book Design
Suzanna M.W.

Production & Layout
Christa Carter

Creating Logo Families
First published in 2000 by HBI,
an imprint of HarperCollins Publishers
10 East 53rd Street
New York, NY 10022-5299

Hardcover ISBN: 0688-17975
Paperback ISBN: 0-06-095844-8

Distributed to the trade and art markets in the U.S. by
North Light Books,
an imprint of F&W Publications, Inc.
1507 Dana Avenue
Cincinnati,OH 45207
Tel: (800) 289-0963

Distributed throughout the rest of the world by
HarperCollins International
10 East 53rd Street
New York, NY 10022-5299
Fax: (212) 207-7654

First published in Germany by Nippan
Nippon Shuppan Hanbai
Deutschland GmbH
Krefelder Strasse 85
D-40549 Dusseldorf
Tel: (0211) 5048089
Fax: (0211) 5049326
ISBN: 3-931884-70-8

©Copyright 2000 HBI and David E. Carter

Printed in Hong Kong by Everbest Printing Company through
Four Colour Imports, Louisville, Kentucky.

Part of my goal as a book editor is to come up with cutting-edge concepts for new publications. In recent years, I have noticed a trend of "logo families"—a set of designs with a common corporate link, as well as a common visual connection.

As I watched new examples of this trend appear, it soon became apparent that this was a very good way of establishing—and solidifying—brand identity. A "logo family" can enhance the identity of a small business, and add additional distinctiveness to larger firms. The design techniques here have an extensive range. In addition, the business categories cover a wide spectrum.

As you flip through this book, you are sure to see many ideas that will help springboard your creativity to new levels in a segment of corporate identity that is very fresh and new...and that, in a nutshell, is the purpose of this book.

David E. Carter

Creating Logo Families

designed by
John Hornall, Paula Cox, Brian O'Neill, & Lian Ng
at
Hornall Anderson Design Works
Seattle, Washington
for
Integrus Corporation

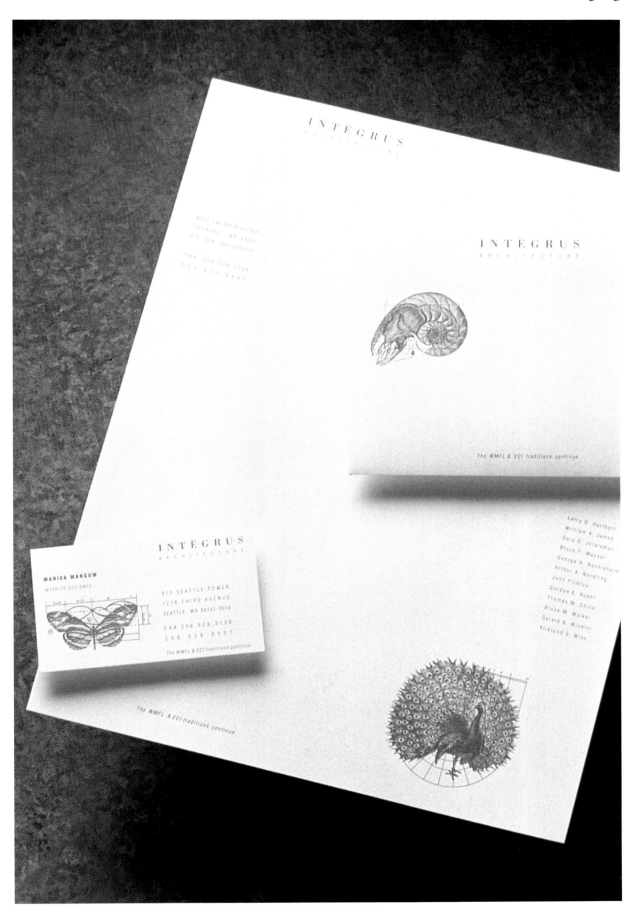

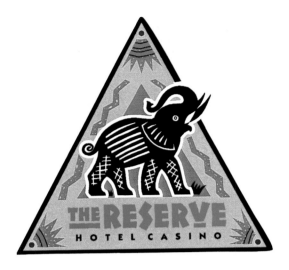

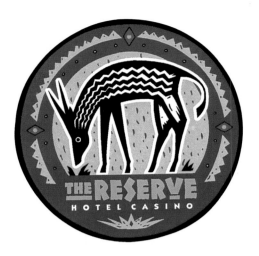

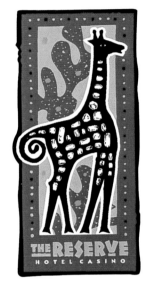

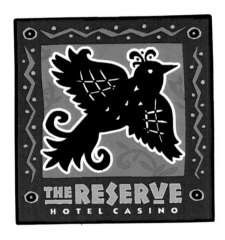

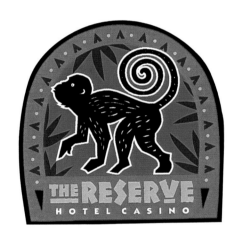

"Six different logos were developed to be used together as a collection. The hotel and casino are heavily-themed with an African adventure motif."

art directed by
 MaeLin Levine & Amy Jo Levine
designed by
 Joel Sotelo
and illustrated by
 David Diaz
at
 Visual Asylum
 San Diego, California
for
 The Reserve Hotel Casino

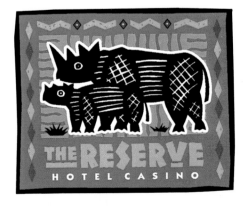

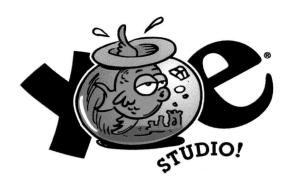

designed by
 Bob Shea
at
 Yoe! Studio
 Peekskill, New York
for
 Yoe! Studio

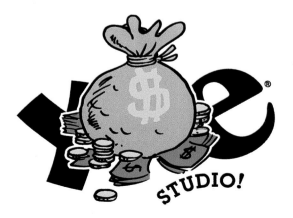

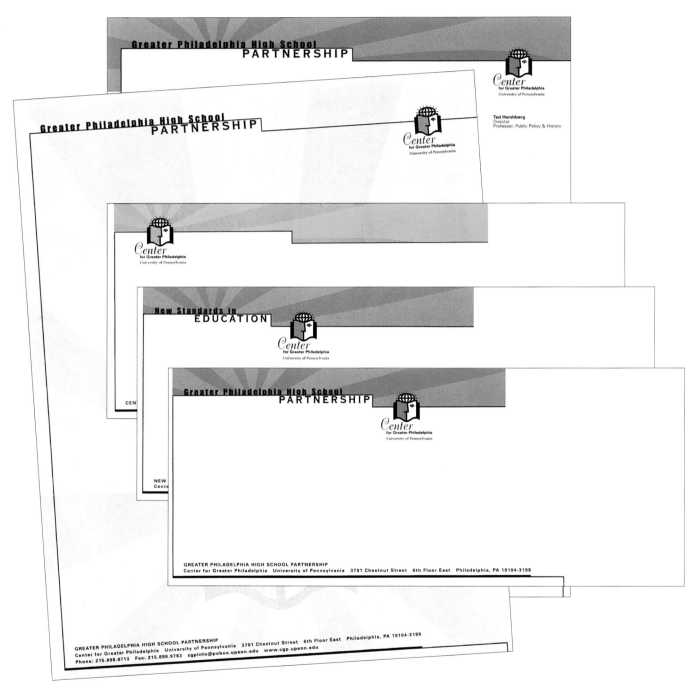

creatively directed by
 Lori Banks
and designed by
 John German & Travis Schnupp
at
 LF Banks + Associates
 Philadelphia, Pennsylvania
for
 Center for Greater Philadelphia

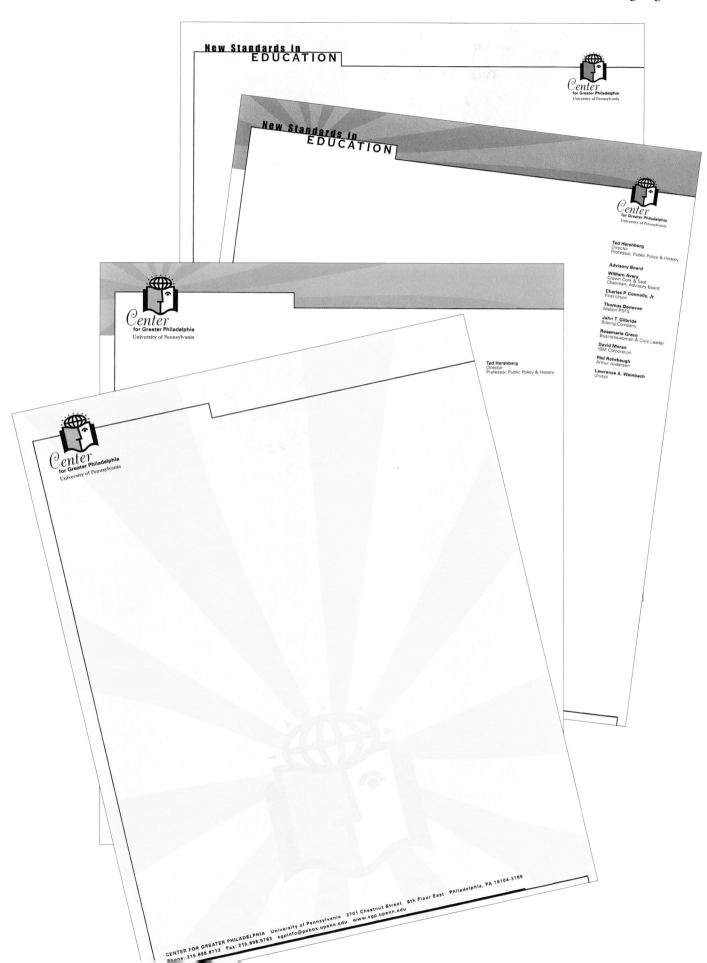

designed by
Mike Quon
at
Mike Quon/Designation
New York, New York
for
Dell Computers

designed by
Thomas G. Fowler
at
Tom Fowler, Inc.
Stamford, Connecticut
for
Tom Fowler, Inc.

designed by
John R. Menter & Walter M. Herip
at
Herip Associates
Peninsula, Ohio
for
Kellam Associates

designed by
Tina Hong & Christen Kucharik
at
Design Continuum Inc.
West Newton, Massachusetts
for
Instrumentation Metrics, Inc.

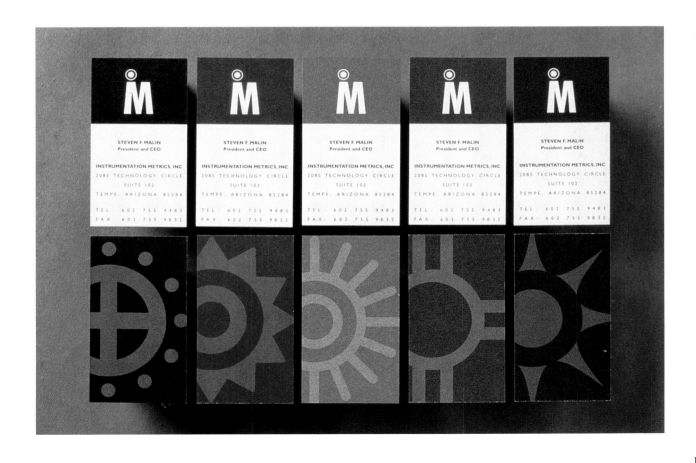

EASTLAND
MALL

JEFFERSON
MALL

designed by
 John R. Menter, Walter M. Herip, & Rick Holb
at
 Herip Associates
 Peninsula, Ohio
for
 The Richard E. Jacobs Group

Hooked On Phonics®
• Learn to Read •

designed by
 Mr. Tharp, Nicole Coleman, & Gina Kim-Mageras
at
Tharp Did It
 Los Gatos, California
for
 Gateway Learning Corp.

designed by
Jack Anderson, David Bates, & Sonja Max
at
Hornall Anderson Design Works
Seattle, Washington
for
Mondeo

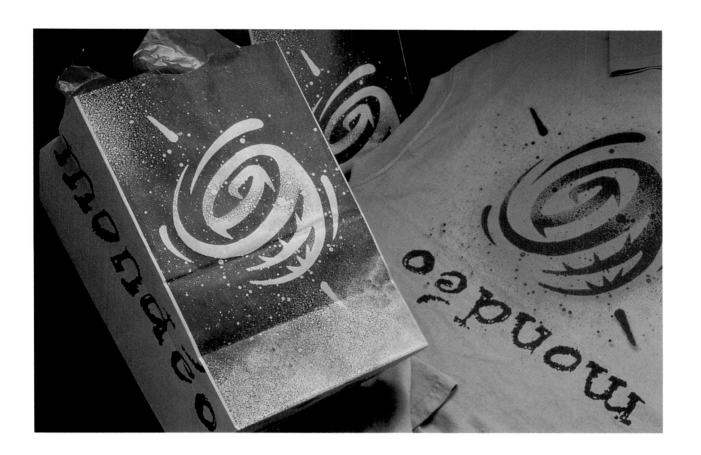

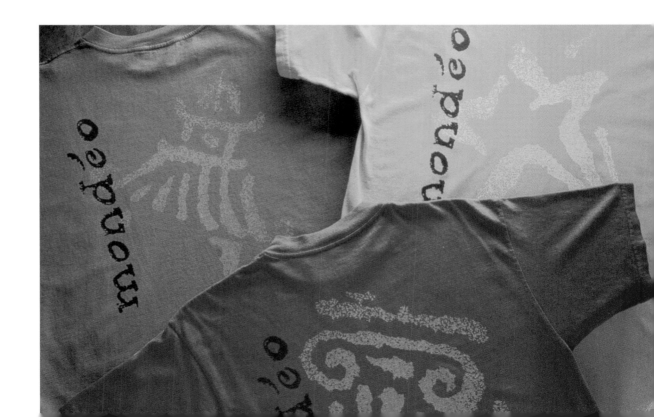

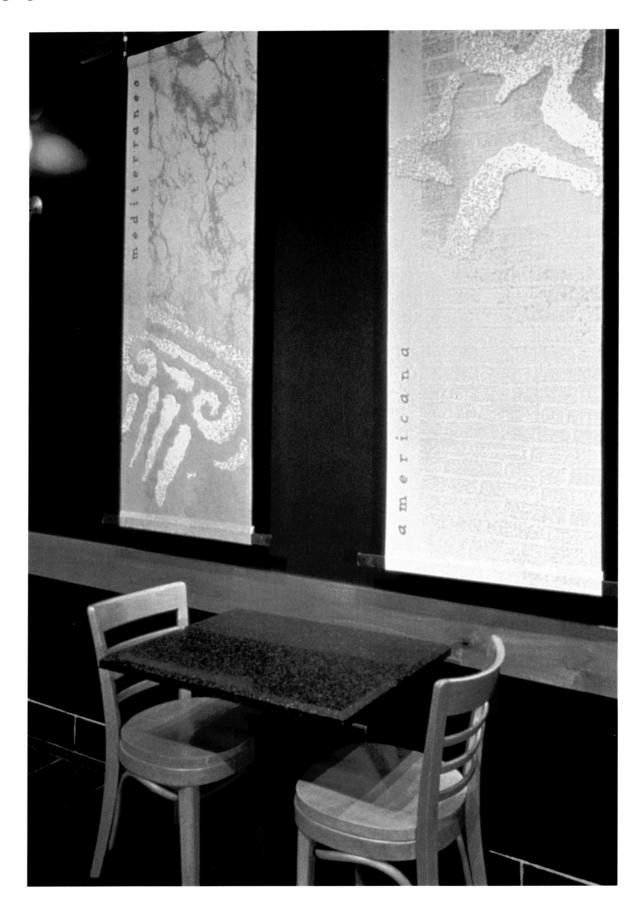

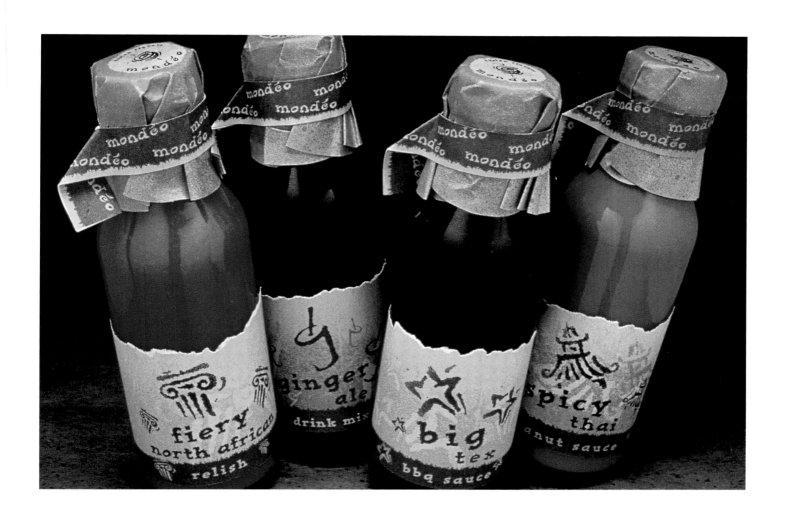

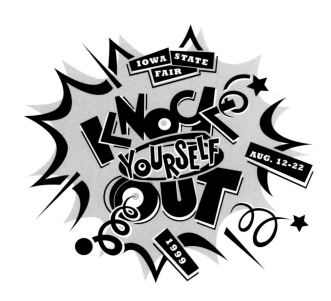

designed by
 John Sayles
at
Sayles Graphic Design
 Des Moines, Iowa
for
 1999 Iowa State Fair

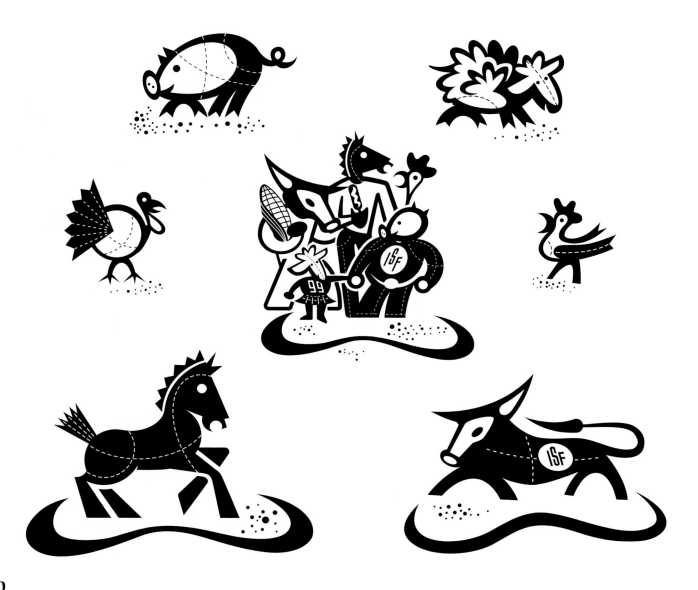

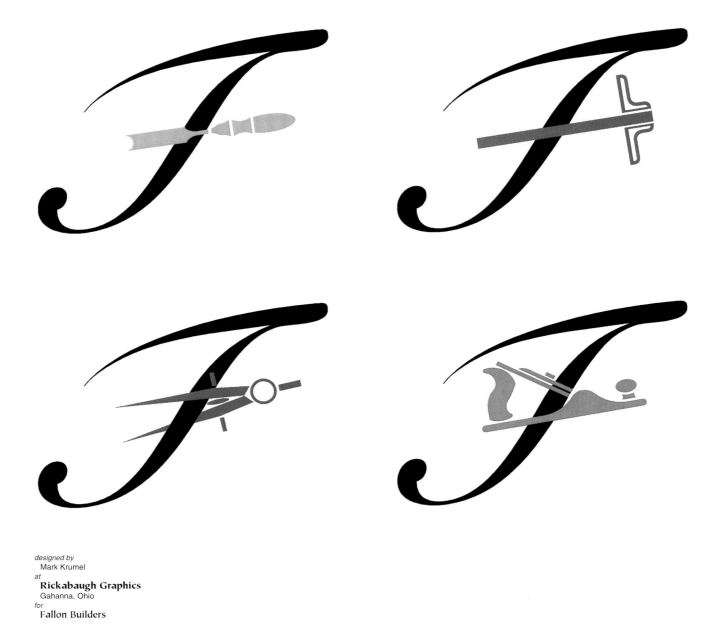

designed by
 Mark Krumel
at
 Rickabaugh Graphics
 Gahanna, Ohio
for
 Fallon Builders

designed by
 Jack Anderson, Julia LaPine, Denise Weir,
 Brian O'Neill, Julie Lock, Jani Drewfs,
 David Bates, John Anicker, & Mary Hermes
at
 Hornall Anderson Design Works
 Seattle, Washington
for
 K2 Corporation

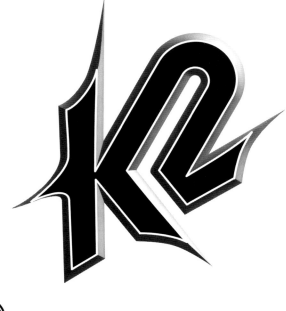

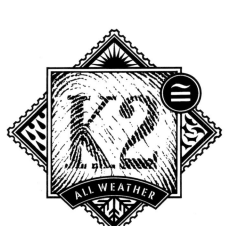

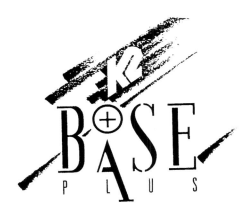

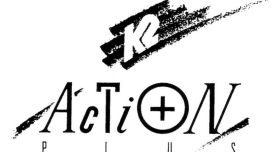

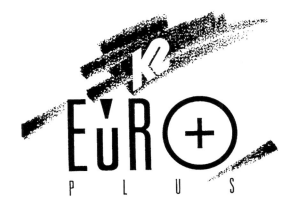

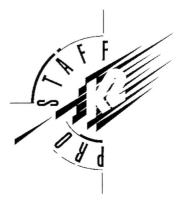

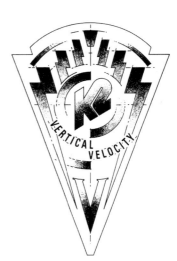

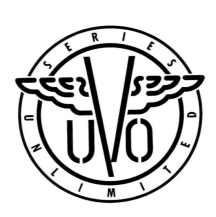

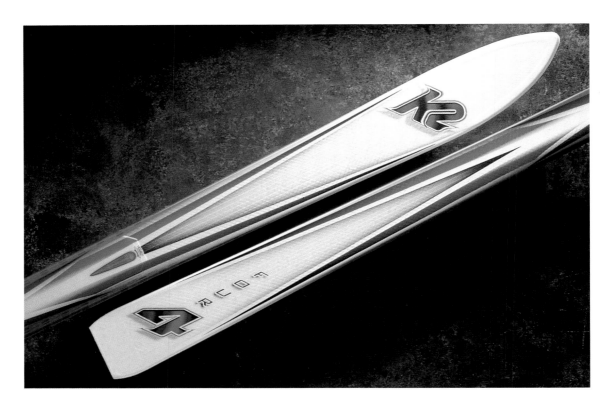

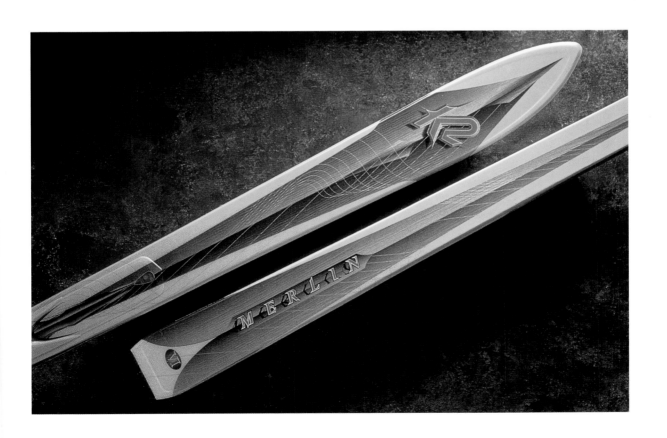

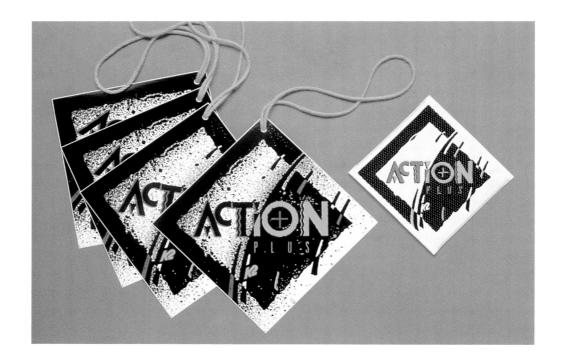

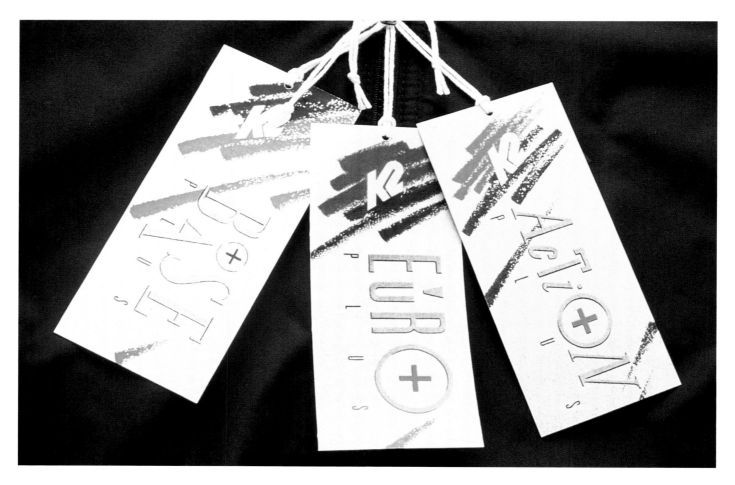

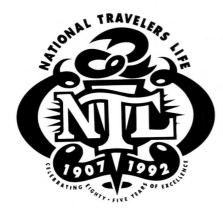

designed by
 John Sayles
at
Sayles Graphic Design
Des Moines, Iowa
for
National Travelers Life

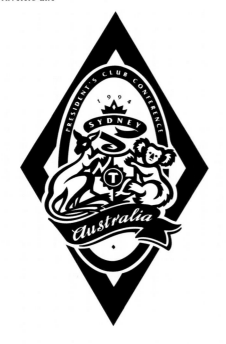

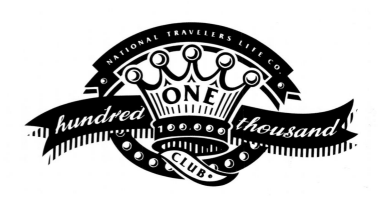

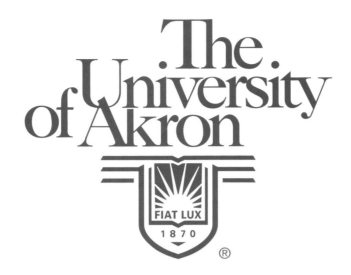

designed by
John R. Menter & Walter M. Herip
at
Herip Associates
Peninsula, Ohio
for
The University of Akron

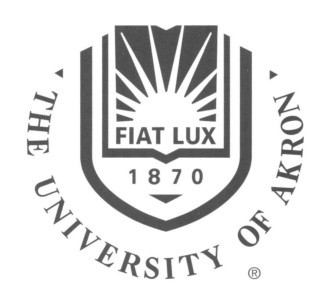

(opposite)
designed by
John Cabot Lodge, Alison Manley,
& Robert Coleman
at
Iconixx
Bethesda, Maryland
for
Columbia Energy Group

Columbia Energy Group ℠

Columbia Gas® of Kentucky

Columbia Gas® of Maryland

Columbia Gas® of Ohio

Columbia Gas® of Virginia

Columbia Gas® of Pennsylvania

Columbia Gas Transmission ℠

Columbia Gulf Transmission ℠

Columbia LNG Corporation ℠

Columbia Propane ℠

Columbia Navigator ℠

Columbia Insurance Corporation, Ltd. ℠

TriStar Capital ℠

Columbia Energy Services ℠

Columbia Energy Group Capital Corporation ℠

Columbia Energy Group Service Corporation ℠

Columbia Energy ℠

Columbia Energy Retail Corp. ℠

Columbia Energy Power Marketing ℠

Columbia Atlantic Trading ℠

Columbia Assurance Agency ℠

Columbia Service Partners ℠

Columbia Natural Resources ℠

Columbia Petroleum Corporation ℠

Columbia Deep Water Services ℠

CNS Microwave ℠

Hawg Hauling & Disposal, Inc. ℠

Columbia Network Services Corp. ℠

Columbia Pipeline Corporation ℠

29

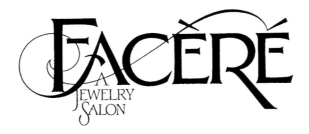

designed by
 Jack Anderson & Juliet Shen
at
 Hornall Anderson Design Works
 Seattle, Washington
for
 Facere Jewelry Art

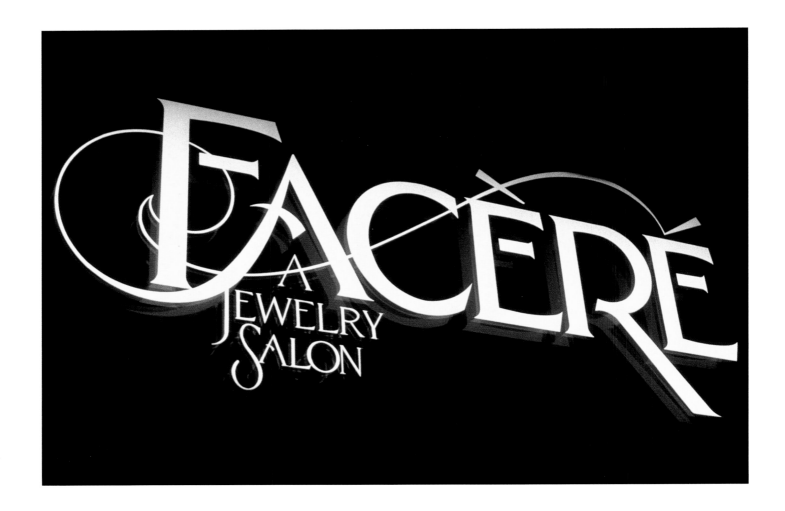

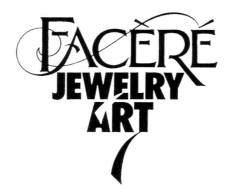

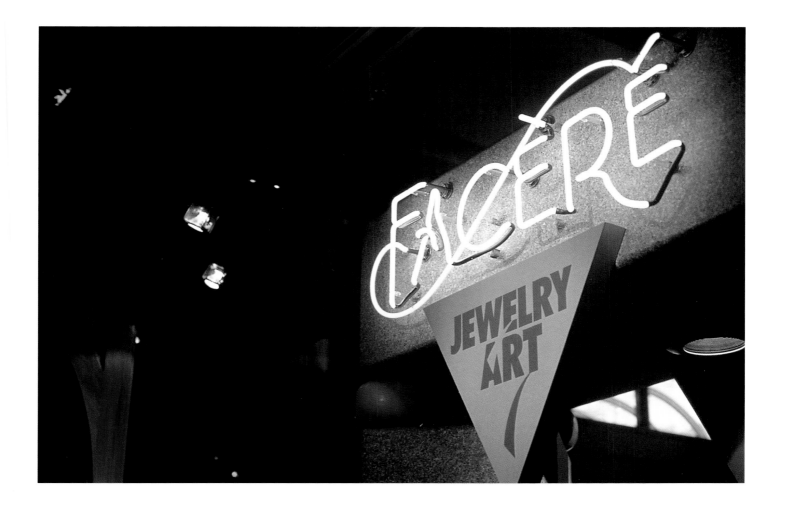

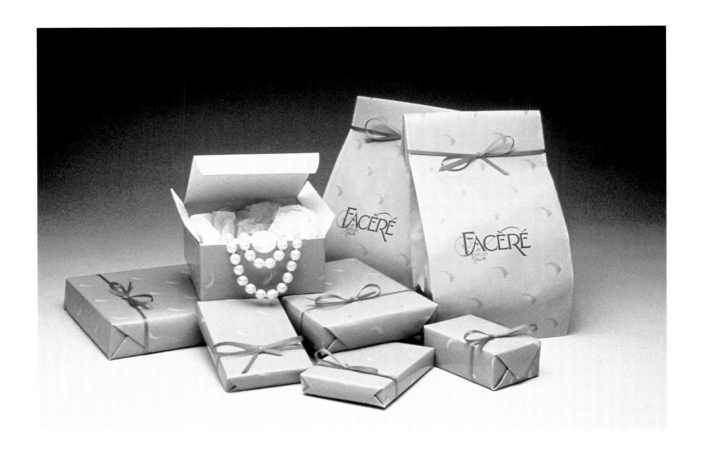

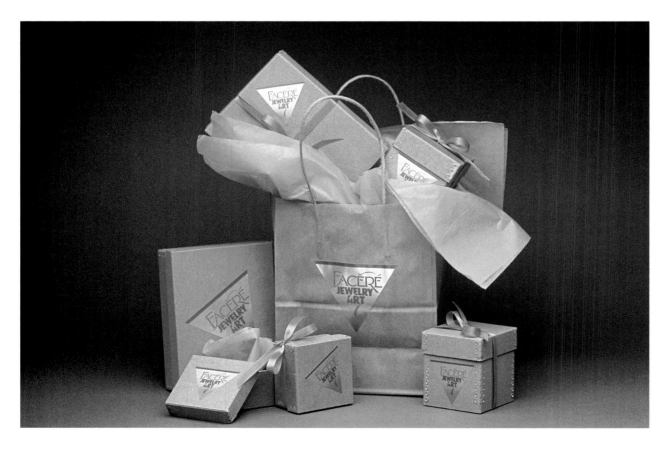

designed by
 John R. Menter & Walter M. Herip
at
Herip Associates
 Peninsula, Ohio
for
Buchanan Industries

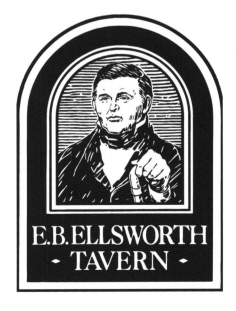

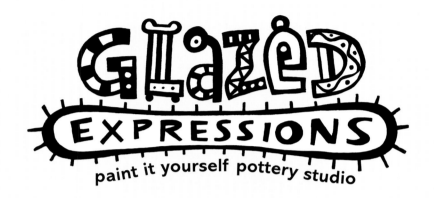

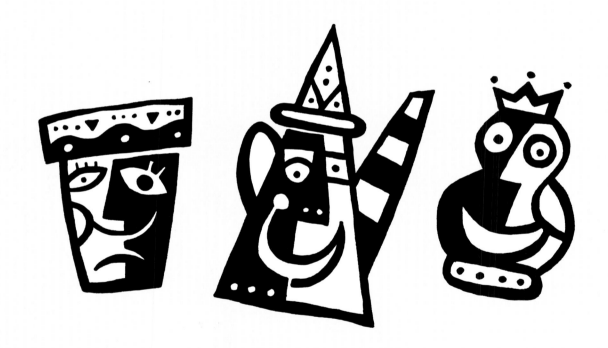

designed by
 John Sayles
at
Sayles Graphic Design
 Des Moines, Iowa
for
 Glazed Expressions

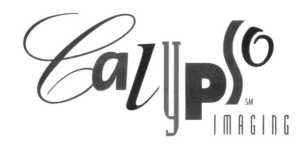

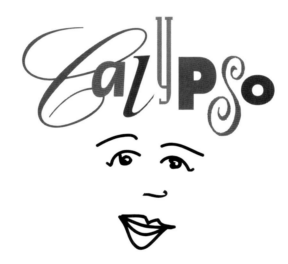

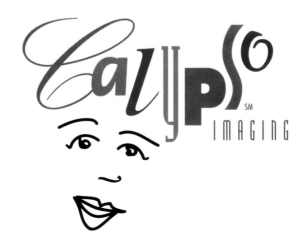

designed by
 Tracy Moon & Michelle Gottlieb
at
 AERIAL
 San Francisco, California
for
 Calypso Imaging, Inc.

designed by
Jackson Boelts, Kerry Stratford,
Eric Boelts, & Elicia Taylor
at
Boelts Bros. Associates
Tucson, Arizona
for
Southwest Parks

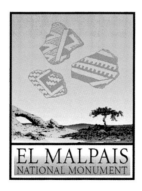

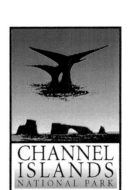

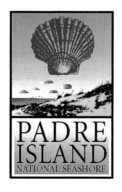

CHACO
CULTURE
NATIONAL HISTORICAL PARK

GOLDEN
SPIKE
NATIONAL HISTORIC SITE

TONTO
NATIONAL MONUMENT

LITTLE
BIGHORN
BATTLEFIELD
NATIONAL MONUMENT

NAVAJO
NATIONAL MONUMENT

TUMACACORI
NATIONAL HISTORICAL PARK

HUBBELL
TRADING POST
NATIONAL HISTORIC SITE

SALINAS
PUEBLO MISSIONS
NATIONAL MONUMENT

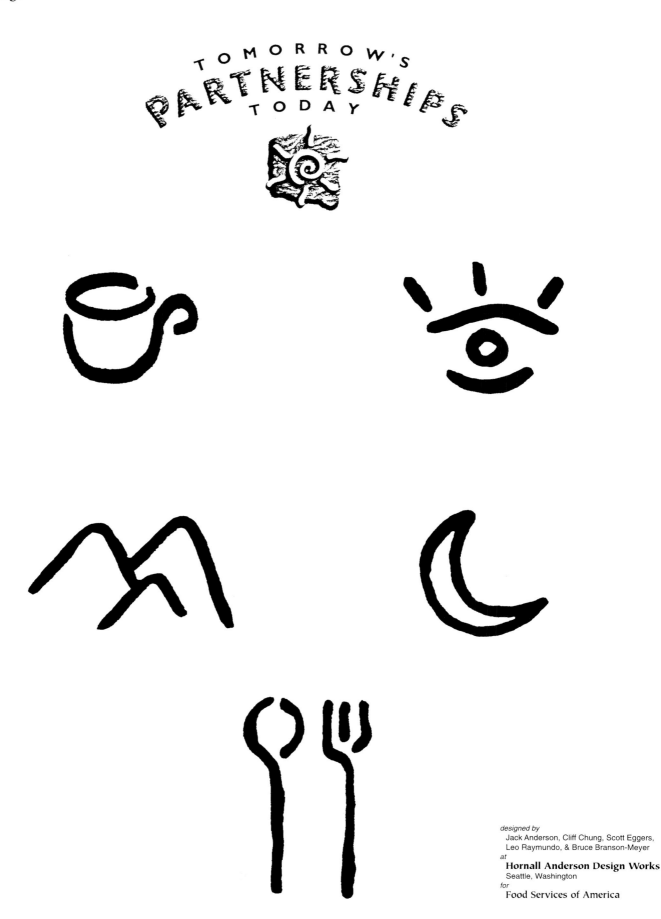

designed by
Jack Anderson, Cliff Chung, Scott Eggers,
Leo Raymundo, & Bruce Branson-Meyer
at
Hornall Anderson Design Works
Seattle, Washington
for
Food Services of America

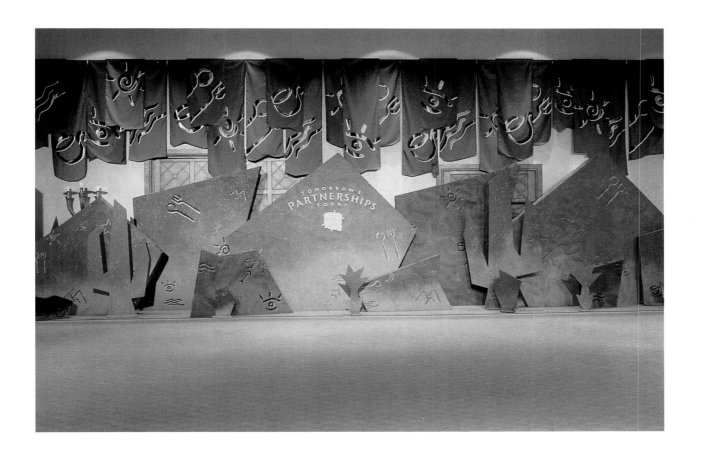

designed by
Jack Anderson, Debra McCloskey, Larry Anderson, & Sonja Max
at
Hornall Anderson Design Works
Seattle, Washington
for
Novell, Inc.

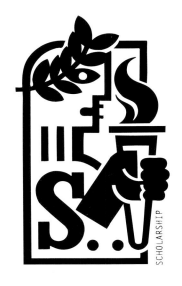

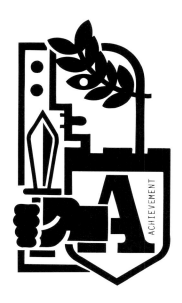

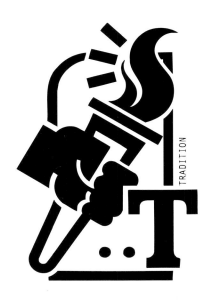

designed by
 John Sayles
at
 Sayles Graphic Design
 Des Moines, Iowa
for
 Drake University

(Employment
Opportunities)

(Clients &
Testimonials)

(Services &
Capabilities)

(Global
Locations)

(Newsroom)

(Contact Us)

(Under
Development)

(Icons for Electronic Media and Industry Segments)

(Site Map)

(Awards &
Publications)

(Industrial)

(High Tech)

(Medical &
Pharmaceutical)

(Financial)

(Consumer)

designed by
Logan Watts
at
Addison Whitney
Charlotte, North Carolina
for
Addison Whitney

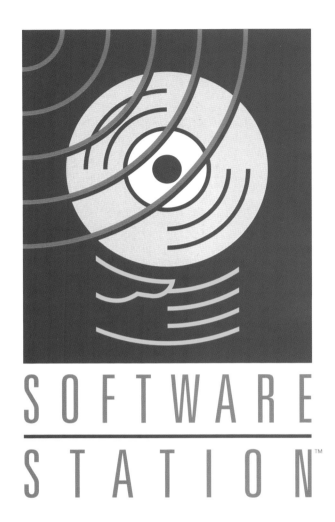

"The IBM Software Station is a 'software vending machine' which uses satellite transmission to enable consumers to demo, place orders, and take delivery of the latest software directly from the kiosk."

art directed & designed by
 Earl Gee
at
 Gee + Chung Design
 San Francisco, California
for
 IBM Corporation

TOUCH'N PREVIEW

LEARN'N BROWSE

VALUE PRICING

INSTANT DELIVERY

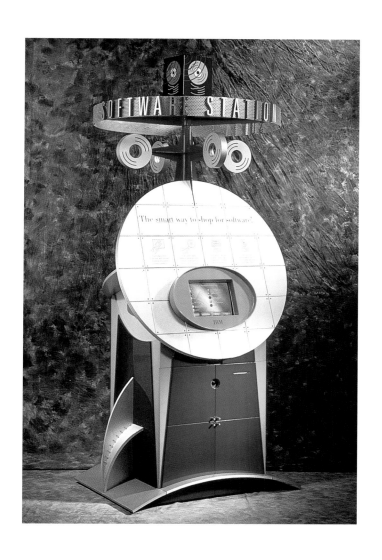

designed by
 Thomas G. Fowler
at
 Tom Fowler, Inc.
 Stamford, Connecticut
for
 Hilltop

art directed & designed by
Earl Gee
at
Gee + Chung Design
San Francisco, California
for
Reel.com

47

Sheep

Shell I

Shell 2

Native woman shopping

Sydney opera house

Taz devil

Volcano

Warrior

designed by
Eric Boelts, Jackson Boelts, & Kerry Stratford
at
Boelts Bros. Associates
Tucson, Arizona
for
Duty Free Shopping

Native woman juggling fruit

Wave

Crocodile

Dingo

Drink

Eat

Emu

Fish

Go

Native man golf

Native man in hammock

Kangaroo

Koala

Kookabura

Native love

Man gone native

Woman gone native

Young office lady

Palm

Native party man

Native party man 2

Salary man

Sea monster

Shark

designed by
 Denise Ender & Janine Weitenauer
at
 360 Degrees, Inc.
 New York, New York
for
 Lewit & Lewinter

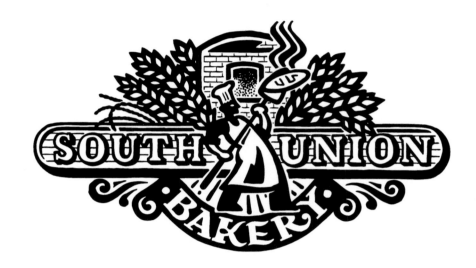

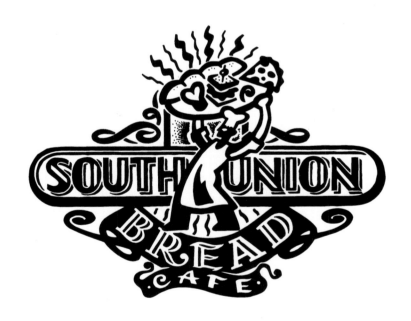

designed by
 John Sayles
at
 Sayles Graphic Design
 Des Moines, Iowa
for
 South Union Bakery & Bread Cafe

designed by
John R. Menter & Walter M. Herip
at
Herip Associates
Peninsula, Ohio
for
Chapman

designed by
 John Sayles
at
 Sayles Graphic Design
 Des Moines, Iowa
for
 Chicago Tribune

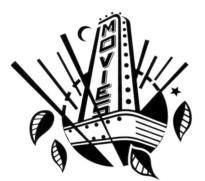

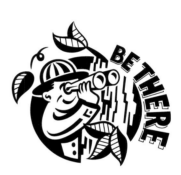

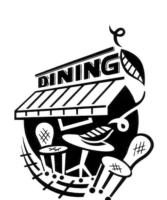

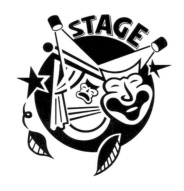

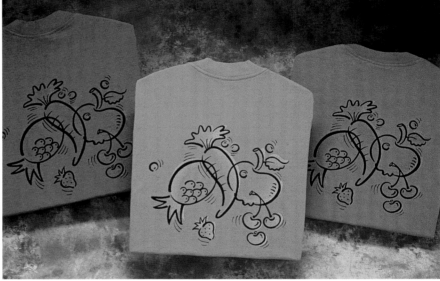

designed by
 Jack Anderson, Lisa Cerveny, & Suzanne Haddon
at
 Hornall Anderson Design Works
 Seattle, Washington
for
 Jamba Juice

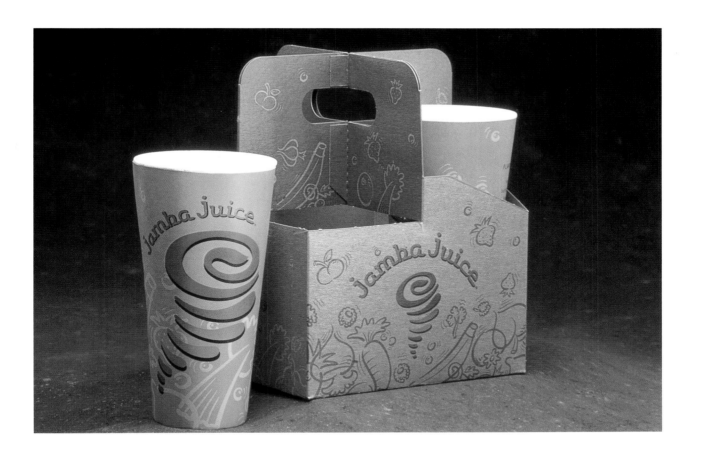

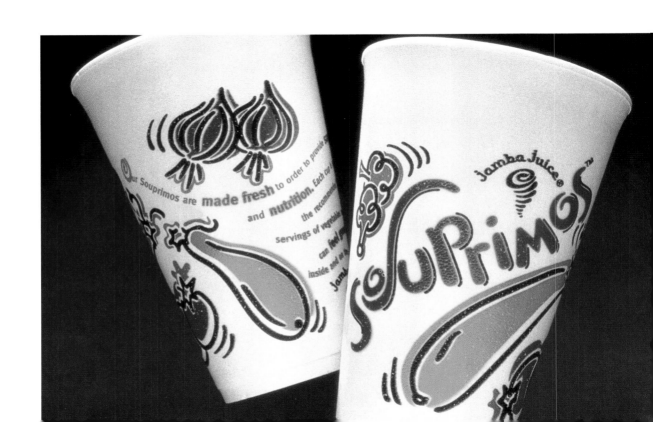

designed by
 John Sayles
at
Sayles Graphic Design
Des Moines, Iowa
for
1997 Iowa State Fair

JUMBO CORN DOGS

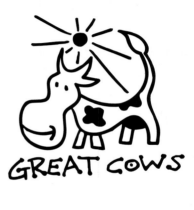

GREAT COWS

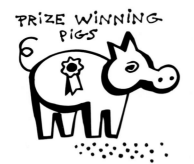

BLUE RIBBONS

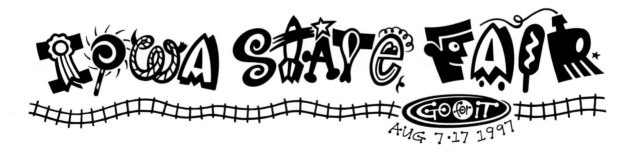

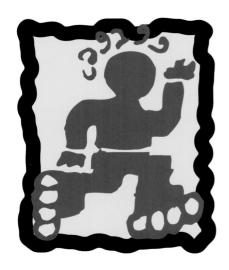 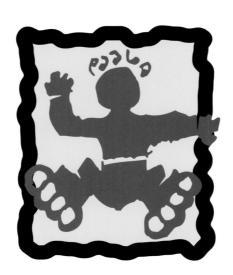 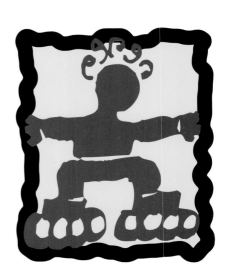

"These logos were designed for Cyko's sport inline wheel series."

designed by
 Alex Valderrama
at
 X Design Company
 Denver, Colorado
for
 Cyko, Inc.

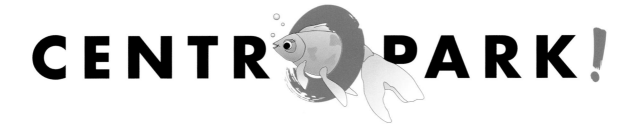

art directed by
 Phillips Engelke
and designed by
 Jill Popowich & Greg Rose
at
 RTKL Associates Inc.
 Baltimore, Maryland
for
 Neve Mitte Projektenwicklung GmbH & Co. KG

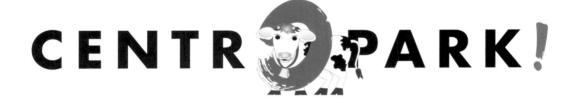

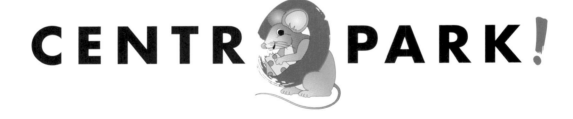

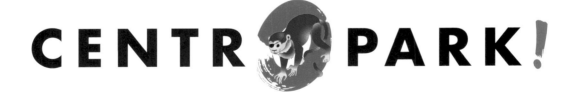

CST Images

designed by
Arne Ratermanis
& Brian Lorenz
at
Lorenz Advertising
San Diego, California
for
CST Images

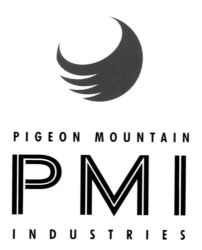

PIGEON MOUNTAIN

PMI

INDUSTRIES

PMI

ROPE ACCESS

PMI

ROPE SPORTS

"The bottom two logos were designed for two subdivisions of the top corporation."

designed by
 Alex Valderrama
at
 X Design Company
 Denver, Colorado
for
 Pigeon Mountain Industries

M O D E R N ▪ I N T E R N A T I O N A L
graphics

M I G I T E C H
hands-on training

P R O C O M
management group

designed by
Susan Lesko
at
Syein & Company
Cleveland, Ohio
for
Modern International Graphic, Inc.

MIGITECH
hands-on training

36600 lakeland blvd.
eastlake ohio 44095
440.946.8900
440.946.4352 fax
1.800.969.5484
www.migitech.com

MODERN ▪ INTERNATIONAL
graphics

36600 lakeland blvd.
eastlake ohio 44095

designed by
Walter M. Herip
at
Herip Associates
Peninsula, Ohio
for
Lake Hospital

designed by
John Sayles
at
Sayles Graphic Design
Des Moines, Iowa
for
Des Moines Art Center

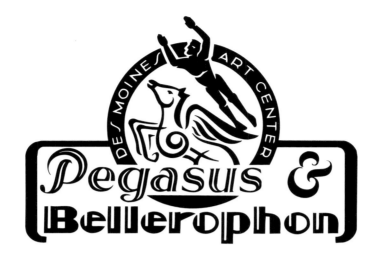

designed by
Jack Anderson
at
Hornall Anderson Design Works
Seattle, Washington
for
Canal Place

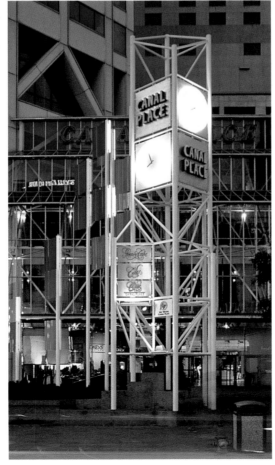

 RIGGS

 RIGGS & CO.

 J. BUSH & CO.

 RIGGS FUNDS

designed by
John Cabot Lodge, Gretchen Frederick, & Roo Johnson
and illustrated by
Mark Summers
at
Iconixx
Bethesda, Maryland
for
Riggs Bank NA

gettuit.com

designed by
Jack Anderson, Kathy Saito, Gretchen Cook,
Julie Lock, James Tee, & Henry Yiu
at
Hornall Anderson Design Works
Seattle, Washington
for
Gettuit.com

workengine

NATIONAL PIPING PRODUCTS

designed by
Uri Kelman
at
Kelman Design Studio
Houston, Texas
for
Universal Metals

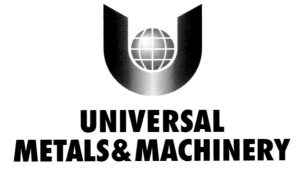

**UNIVERSAL
METALS & MACHINERY**

TECHNICAL ALLOYS

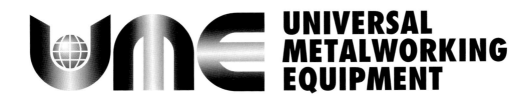

**UNIVERSAL
METALWORKING
EQUIPMENT**

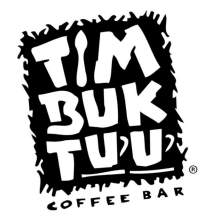
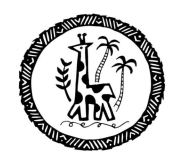

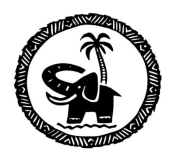
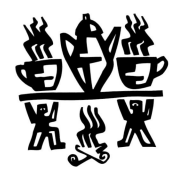
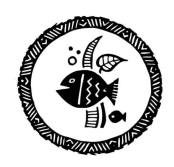

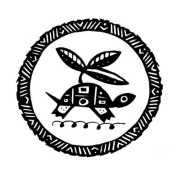
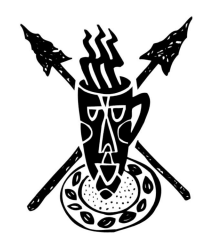
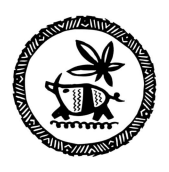

TIMBUKTUU COFFEE BAR®

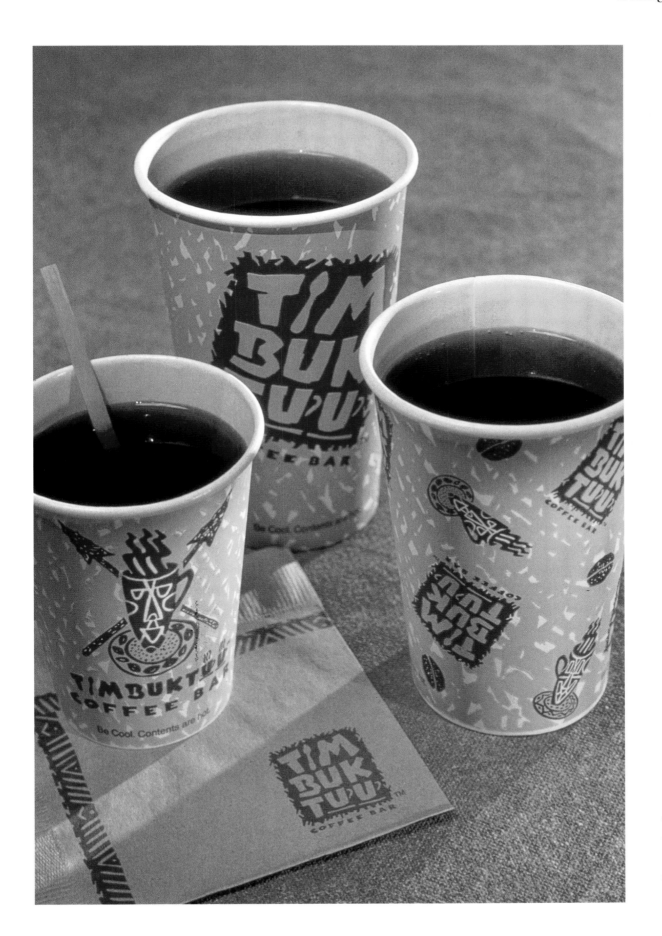

designed by
John Sayles
at
**Sayles
Graphic Design**
Des Moines, Iowa
for
Timbuktuu
Coffee Bar

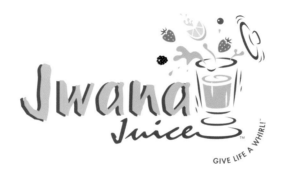

designed by
Isabel Campos
at
Cathey Associates, Inc.
Dallas, Texas
for
Jwana Juice

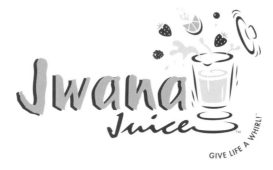

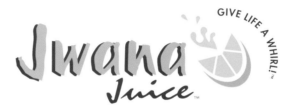

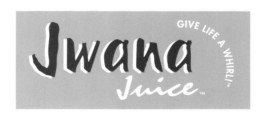

designed by
Ryoichi Yotsumoto
at
Laura Coe Design Associates
San Diego, California
for
DataQuick, a division of Axciom

designed by
 Jack Anderson, Lisa Cerveny,
 Jana Wilson Esser, David Bates, & Nicole Bloss
at
Hornall Anderson Design Works
 Seattle, Washington
for
Best Cellars

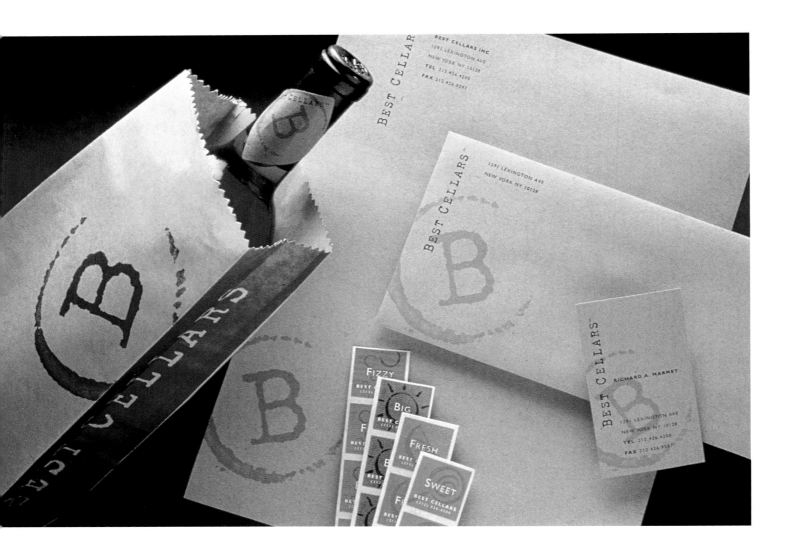

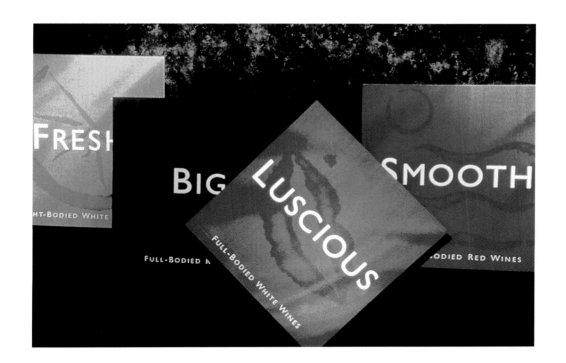

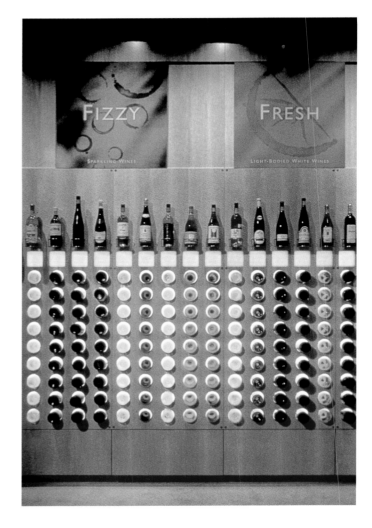

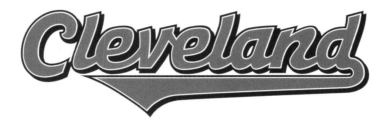

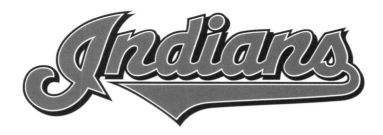

designed by
 John R. Menter & Walter M. Herip
at
 Herip Associates
 Peninsula, Ohio
for
 Cleveland Indians/Jacobs Field
 & Major League Baseball

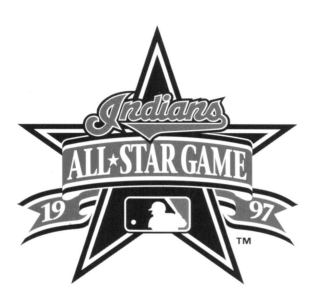

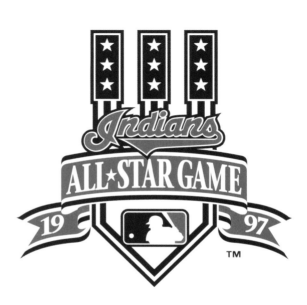

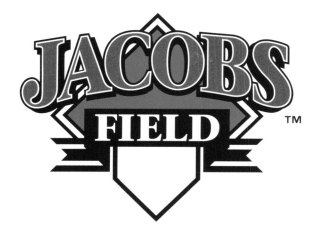

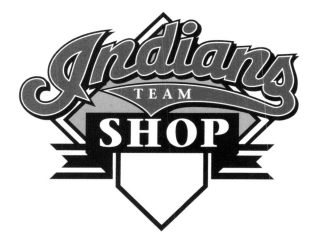

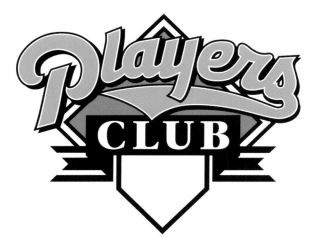

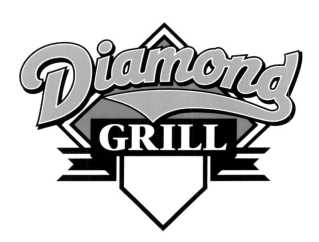

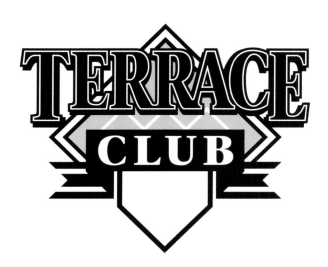

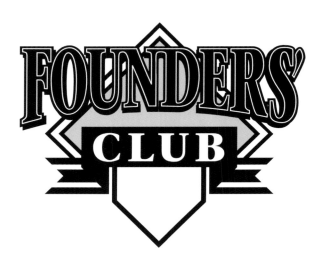

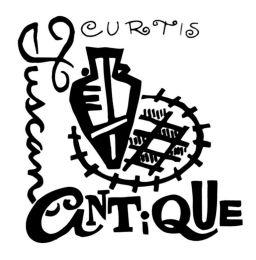

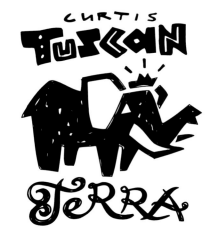

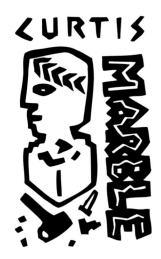

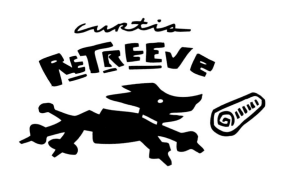

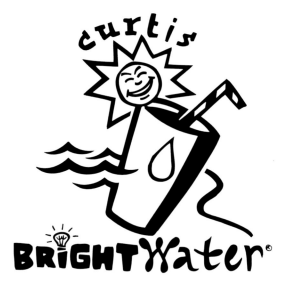

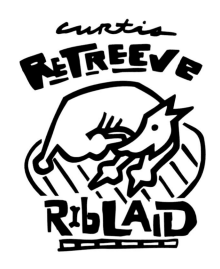

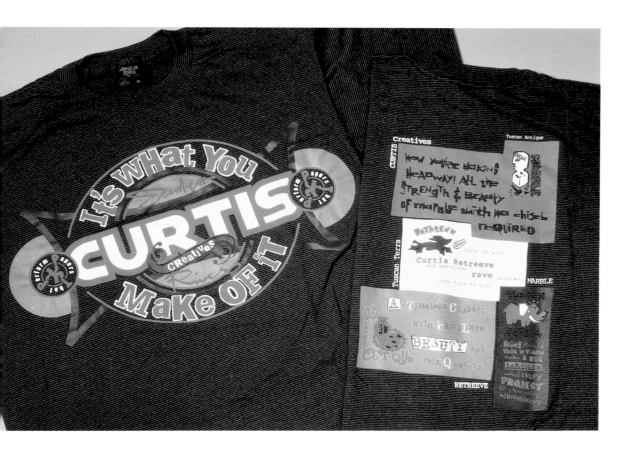

designed by
John Sayles
at
**Sayles
Graphic Design**
Des Moines, Iowa
for
James River Paper

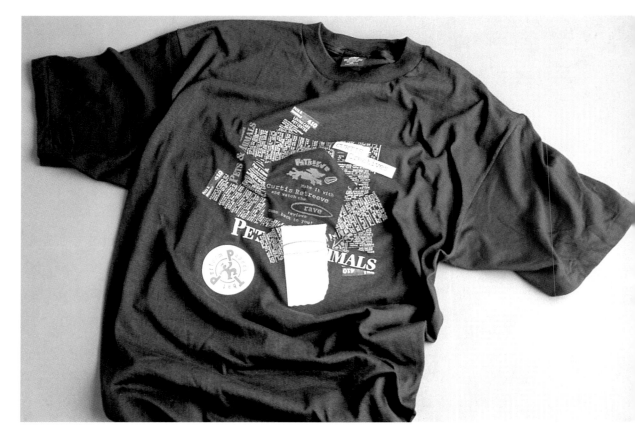

novo interactive

Digital Commerce Architects

creatively directed by
David Salanitro
and designed by
Alice Chang
at
Oh Boy, A Design Company
San Francisco, California
for
Novo Interactive

novo interactive

Digital Commerce Architects

novo interactive

Digital Commerce Architects

novo interactive

Digital Commerce Architects

novo interactive

Digital Commerce Architects

novo interactive

Digital Commerce Architects

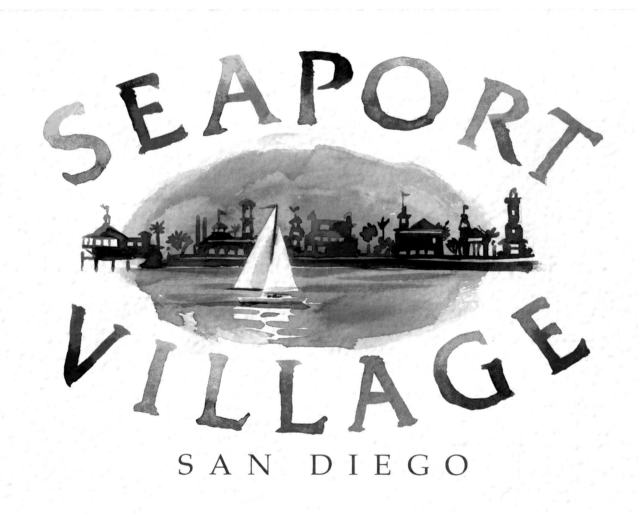

art directed by
 Marilee Bankert
and designed & illustrated by
 Tracy Sabin
at
 Tracy Sabin Graphic Design
 San Diego, California
for
 Seaport Village

SEAPORT VILLAGE

About Us

Directory

Calendar

Fine Food

Photo Tour

E-Mail

designed by
Susan Hochbaum & Steven Guarnaccia
at
Susan Hochbaum Design
Montclair, New Jersey
for
Slavin Schaffer Films

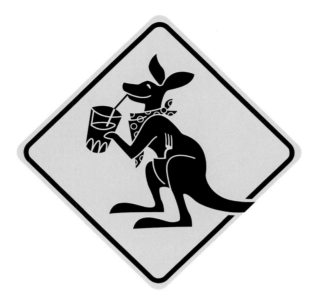

designed by
 Gregory Gersch
at
Bremmer & Goris Communications
 Alexandria, Virginia
for
 Frank Parson's Paper

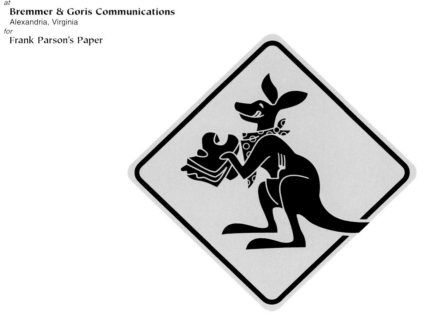

designed by
John R. Menter, Rick Holb, & Walter M. Herip
at
Herip Associates
Peninsula, Ohio
for
Stark Enterprises

CASTILE VENTURES

"Castile is a venture capital firm named after the Spanish city from which Columbus embarked on his journey of exploration and discovery."

art directed by
 Earl Gee
and designed by
 Earl Gee & Kay Wu
at
 Gee + Chung Design
 San Francisco, California
for
 Castile Ventures

art directed by
 Stacy Armstrong
and designed & illustrated by
 Tracy Sabin
at
 Tracy Sabin Graphic Design
 San Diego, California
for
 University Towne Centre

Children's Specialty

Department Stores

Museum

Women's Apparel

Footwear

Men's Apparel

Financial Institutions

Specialty Apparel

Customer Service

General Services

Auto Services

Clue

General Offices

Restaurants

Beauty Salons

Cards & Gifts

Home Furnishings

Specialty Stores

Entertainment

Eateries

Jewelry

Home Entertainment

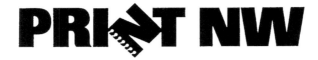

designed by
Jack Anderson, Heidi Favour, & Jani Drewfs
at
Hornall Anderson Design Works
Seattle, Washington
for
Print Northwest

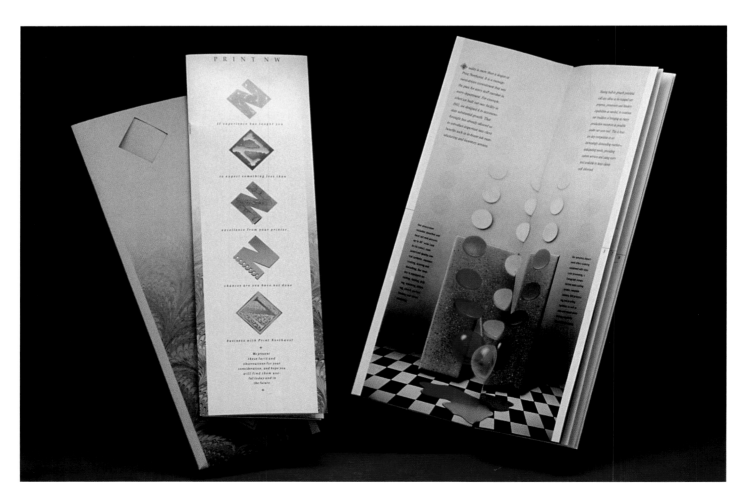

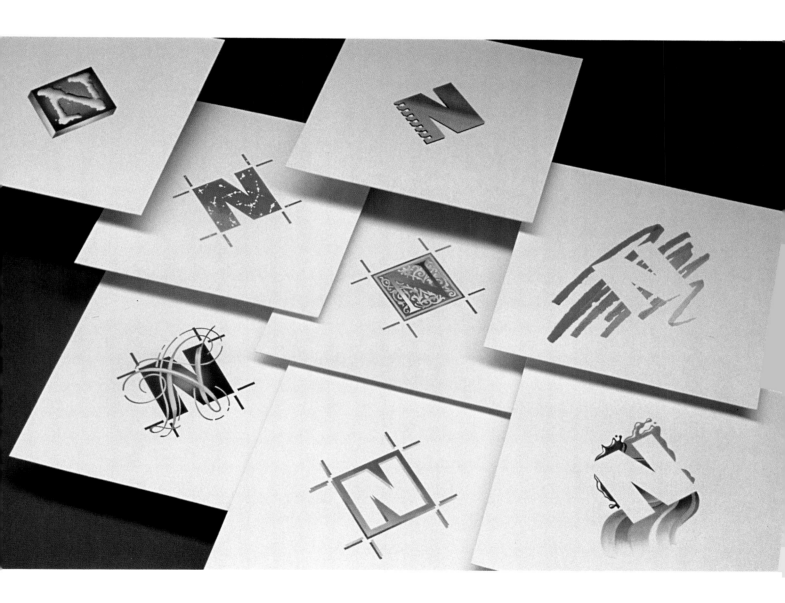

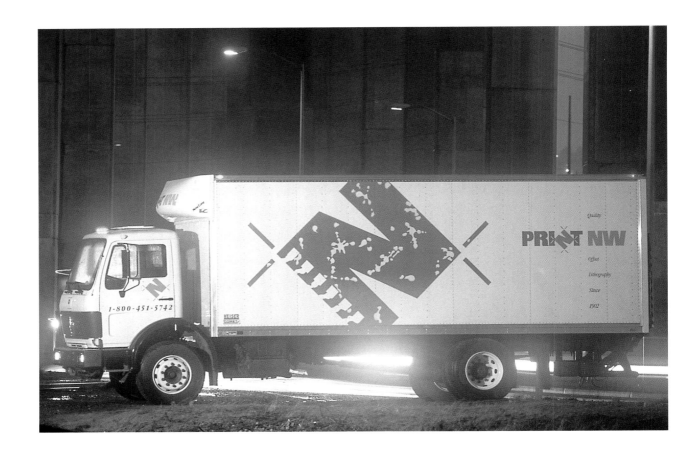

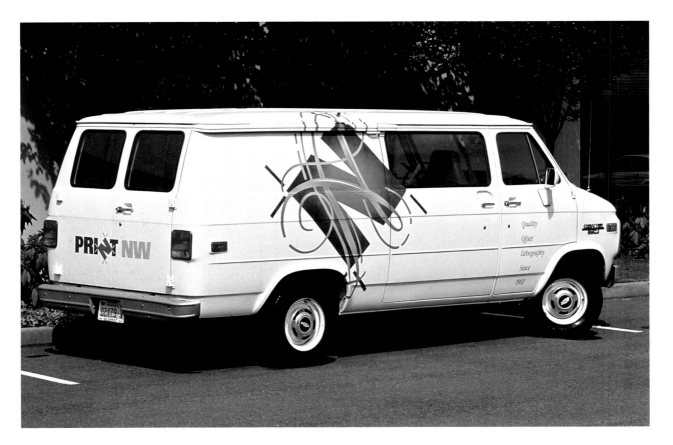

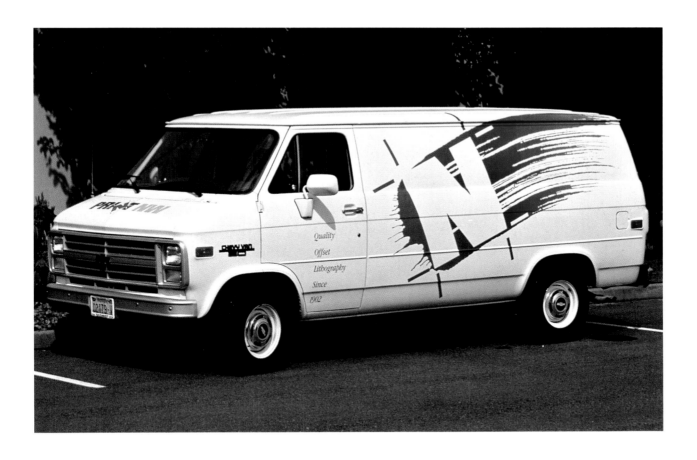

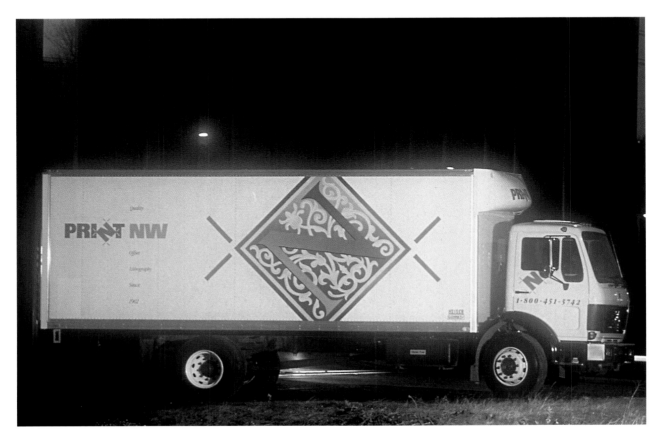

designed by
 Eric Boelts, Jackson Boelts, & Kerry Stratford
at
 Boelts Bros. Associates
 Tucson, Arizona
for
 Boelts Bros. Associates

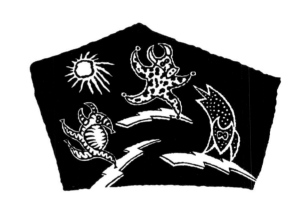

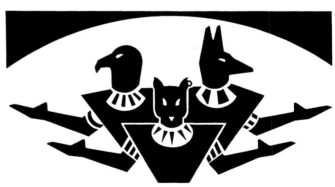

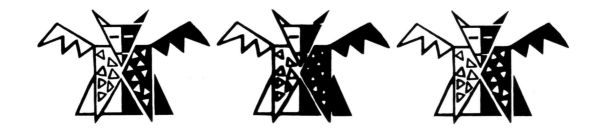

creatively directed & illustrated by
 Steven Morris
with coasters designed by
 Michelle Brodasky
at
 Steven Morris Design, Inc.
 San Diego, California
for
 Steven Morris Design, Inc.

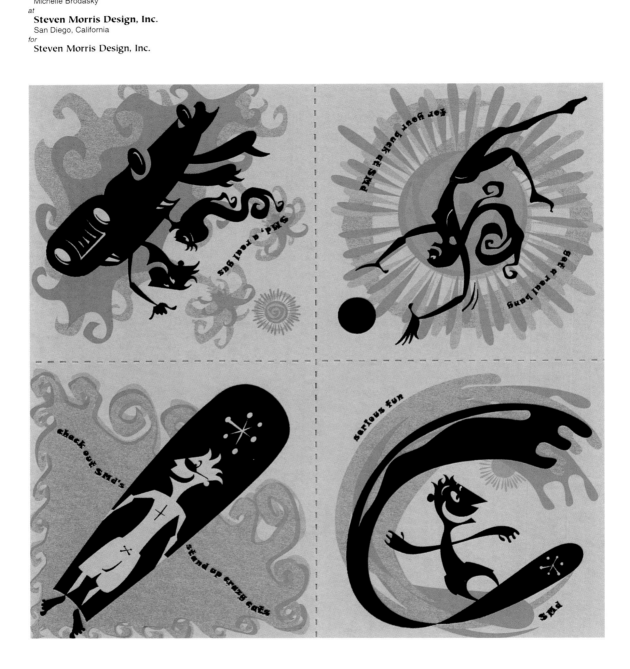

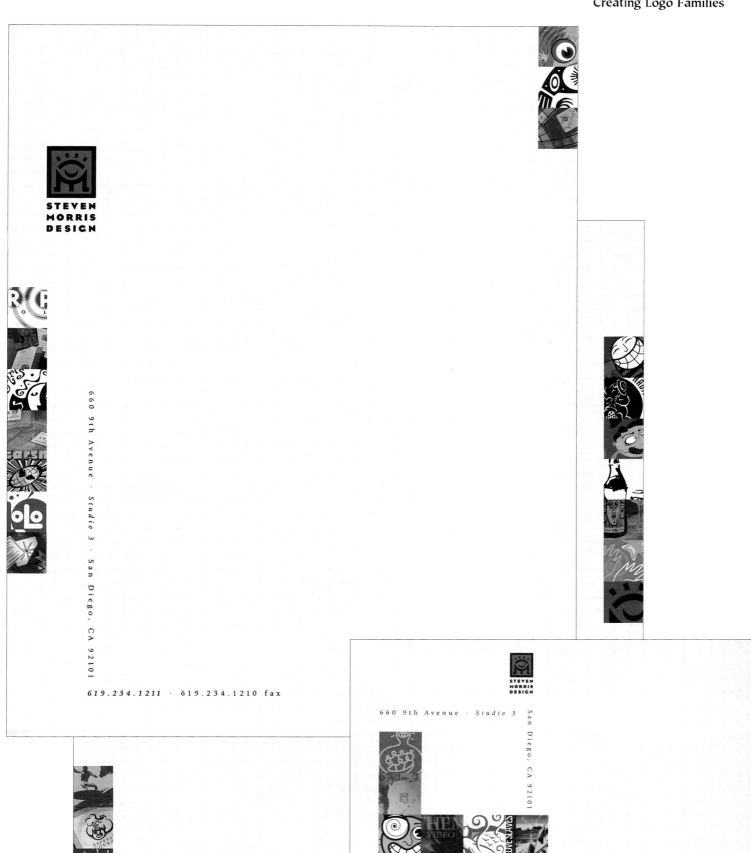

 Los Angeles World Airports

LAX
Los Angeles World Airports

Palmdale
Los Angeles World Airports

Van Nuys
Los Angeles World Airports

designed by
Clifford Selbert, Robin Perkins, Rick Simner,
Jamie Diersing, & Gemma Lawson
at
Selbert Perkins Design Collaborative
Santa Monica, California
Cambridge, Massachusetts
for
The Los Angeles World Airports

PHONE NUMBER

FAX ON DEMAND

ADDRESS

E - M A I L

WEB ADDRESS

designed by
Laura Coe Wright & Ryoichi Yotsumoto
at
Laura Coe Design Associates
San Diego, California
for
Taylor Made Golf Co.

ASYMETRIX

designed by
Jack Anderson, Julie Lock, Denise Weir, Mary Hermes,
Heidi Favour, Brian O'Neill, & Lian Ng
at
Hornall Anderson Design Works
Seattle, Washington
for
Asymetrix Corporation

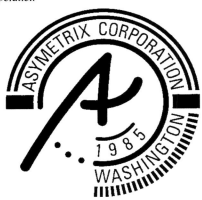

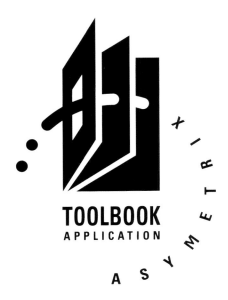

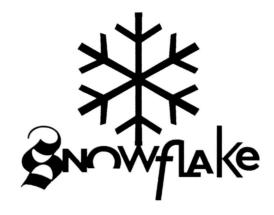

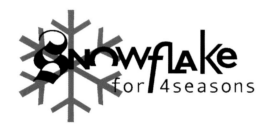

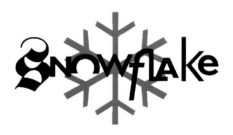

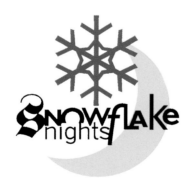

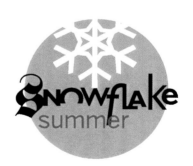

designed by
Gunnar Swanson
at
Gunnar Swanson Design Office
Duluth, Minnesota
for
Snowflake

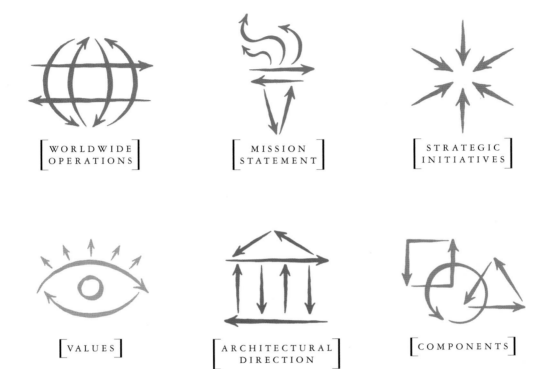

$$\begin{bmatrix} \text{WORLDWIDE} \\ \text{OPERATIONS} \end{bmatrix}$$

$$\begin{bmatrix} \text{MISSION} \\ \text{STATEMENT} \end{bmatrix}$$

$$\begin{bmatrix} \text{STRATEGIC} \\ \text{INITIATIVES} \end{bmatrix}$$

$$\begin{bmatrix} \text{VALUES} \end{bmatrix}$$

$$\begin{bmatrix} \text{ARCHITECTURAL} \\ \text{DIRECTION} \end{bmatrix}$$

$$\begin{bmatrix} \text{COMPONENTS} \end{bmatrix}$$

"These logos were developed for Sun Microsystems Worldwide Operations Program which promotes a unified direction for company operations, embodying the chairman's belief in 'putting all the weight behind one arrow'."

art directed by
 Earl Gee
and designed by
 Earl Gee & Fani Chung
at
 Gee + Chung Design
 San Francisco, California
for
 Sun Microsystems

SECURITY OFFICERS

ELECTRONIC SURVEILLANCE

VEHICLE PATROL

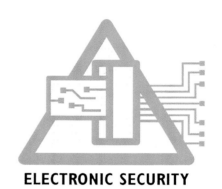

ELECTRONIC SECURITY

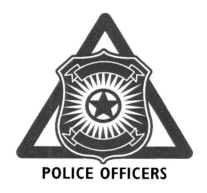

POLICE OFFICERS

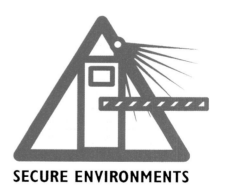

SECURE ENVIRONMENTS

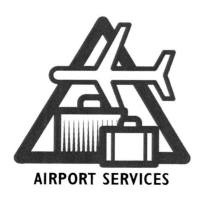

AIRPORT SERVICES

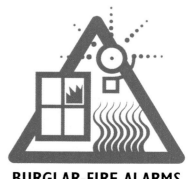

BURGLAR-FIRE ALARMS

designed by
Erick De Martino
at
**De Martino
Design**
Mt. Kisco, New York
for
Haynes
Security, Inc.

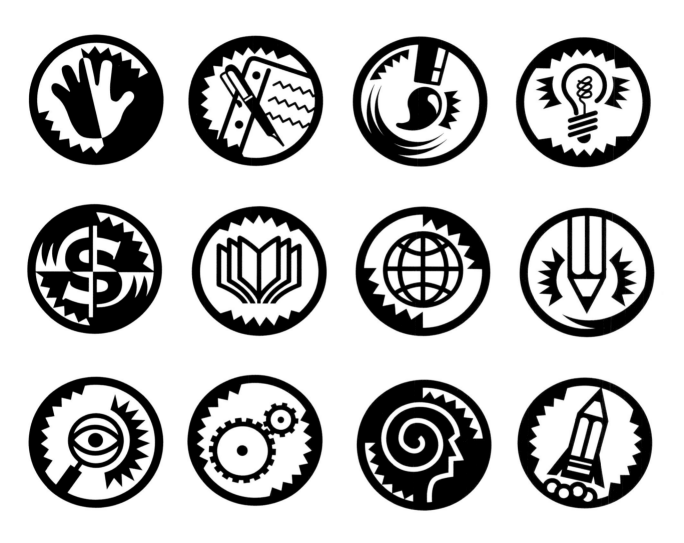

designed by
Donna Aldridge
at
Sibley-Peteet Design
Dallas, Texas
for
Prentice Hall

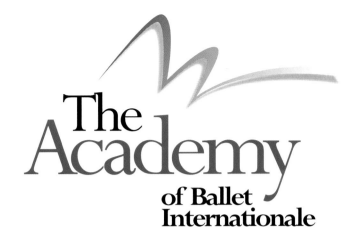

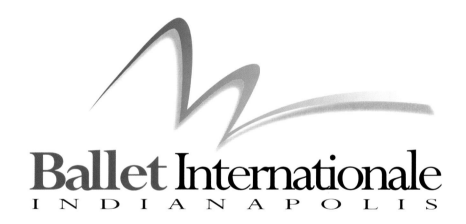

designed by
Steve Nealy
at
Nealy Wilson Nealy, Inc.
Indianapolis, Indiana
for
Ballet Internationale

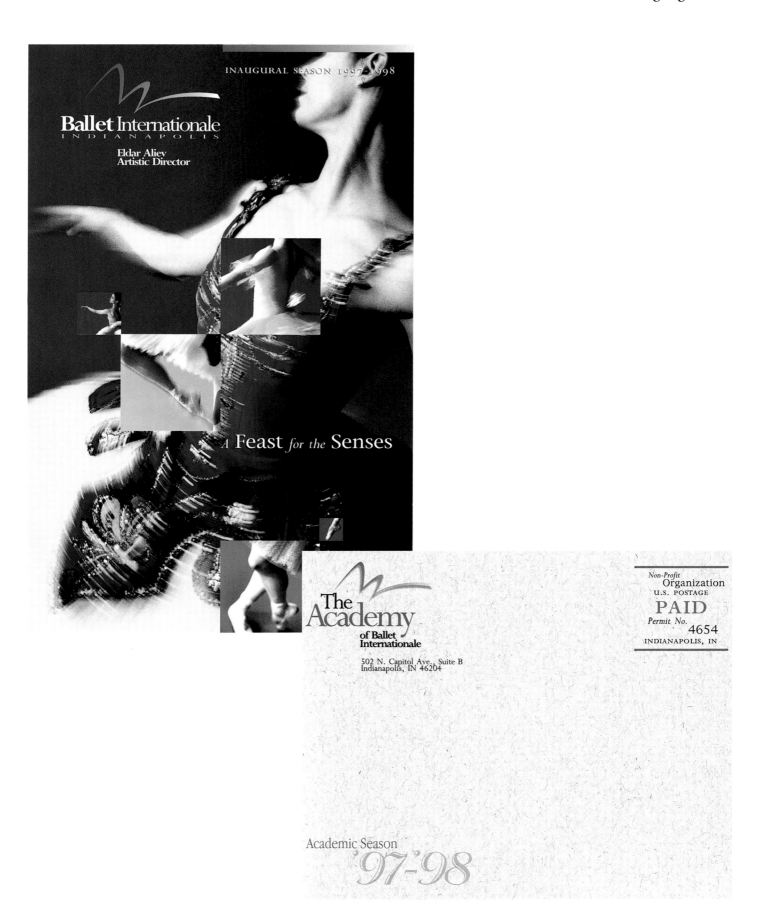

art directed by
 Rita Hoffman
and designed & illustrated by
 Tracy Sabin
at
 Tracy Sabin Graphic Design
 San Diego, California
for
 Taylor Guitars

LETTERS

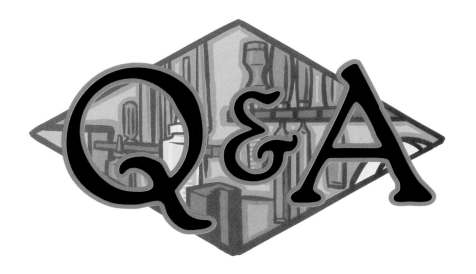

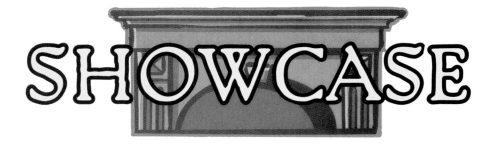

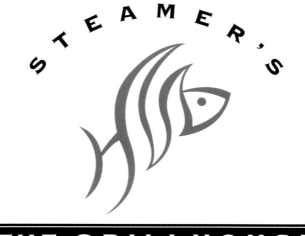

designed by
Mr. Tharp & Nicole Coleman
at
Tharp Did It
Los Gatos, California
for
Steamer's, The Grillhouse

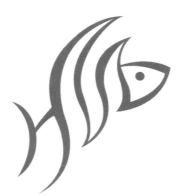

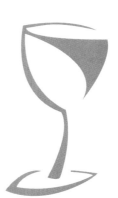

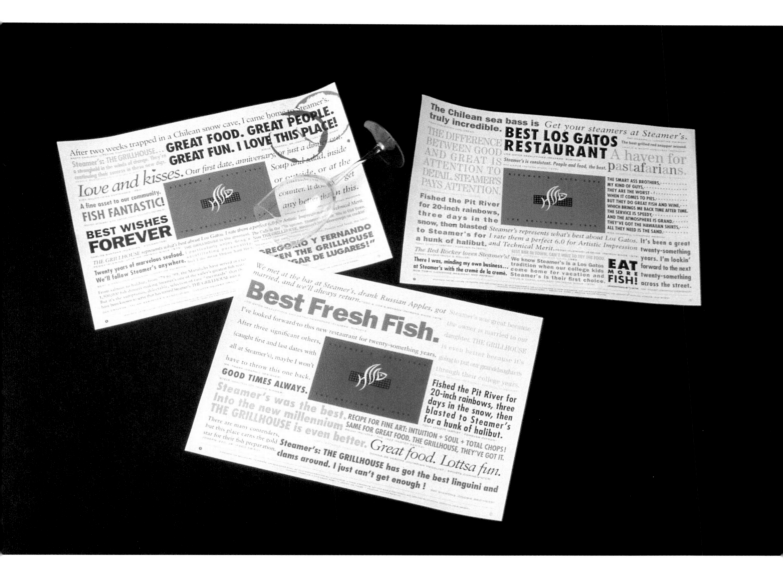

HEAT RETENTION

designed by
Laura Coe Wright & Ryoichi Yotsumoto
at
Laura Coe Design Associates
San Diego, California
for
Road Runner Sports

BREATHABILITY

PERMEABILITY

HARD PRECIPITATION MILD PRECIPITATION LIGHT PRECIPITATION

WIND FACTOR FINE DAY

designed by
John Sayles
at
Sayles Graphic Design
Des Moines, Iowa
for
Microware

designed by
 Fred Cisneros & Harry Forehand III
and illustrated by
 Fred Cisneros & Beth Evans Utley
at
 Cisneros Design
 Santa Fe, New Mexico
for
 Blue Corn Cafe and Brewery

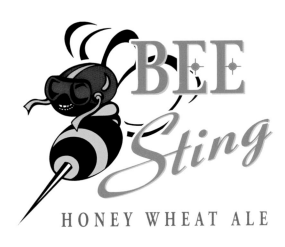

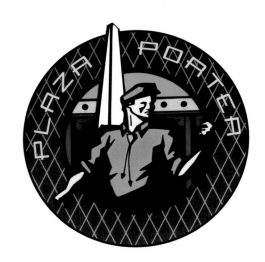

designed by
Jack Anderson & Jani Drewfs
at
Hornall Anderson Design Works
Seattle, Washington
for
Food Connection

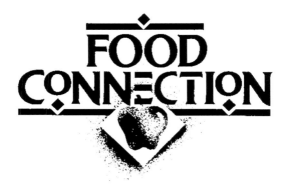

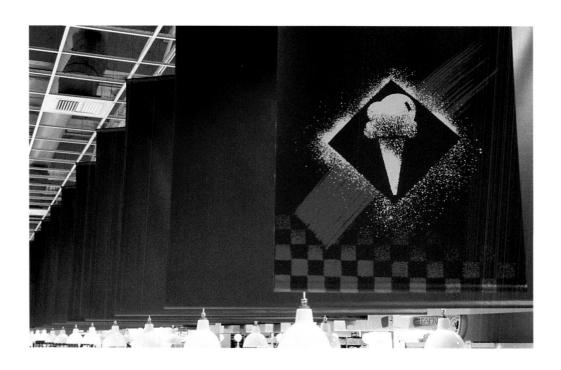

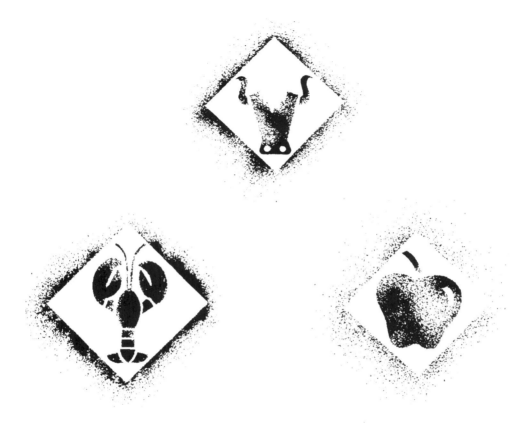

art directed by
 Phillips Engelke
and designed by
 Jill Popowich & Kevin Meiser
at
 RTKL Associates
 Baltimore, Maryland
for
 Mitsui Fudosan

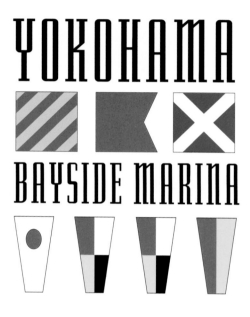

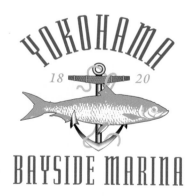

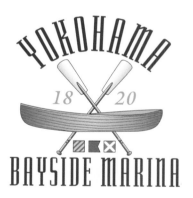

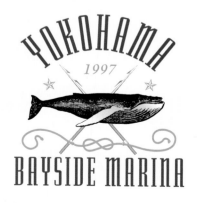

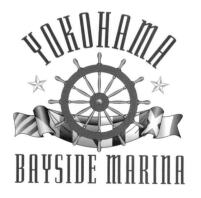

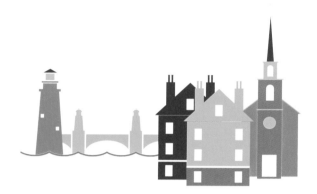

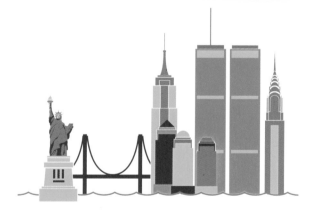

designed by
John R. Menter & Walter M. Herip
at
Herip Associates
Peninsula, Ohio
for
University Hospitals of Cleveland

designed by
David Chapman
and illustrated by
Fritz Dumville
at
**Chapman
and Partners**
Providence, Rhode Island
for
Panache Resources
& Systems Corp

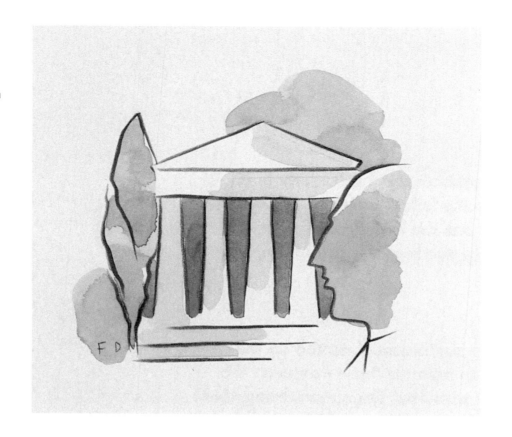

designed by
Tracy Sabin & Blaize McKinna
at
Tracy Sabin Graphic Design
San Diego, California
for
University of California, San Diego

designed by
 Mark Schmitz, Heather Holte, & Cindy Neal-Walker
at
 Z·D Studios
 Madison, Wisconsin
for
 Miller Brewing Company

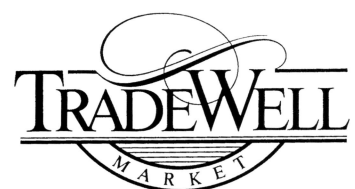

designed by
Jack Anderson & Jani Drewfs
at
Hornall Anderson Design Works
Seattle, Washington
for
Tradewell Market

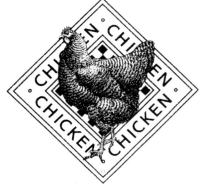

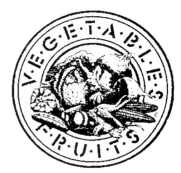

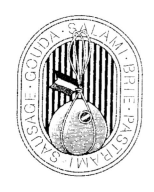

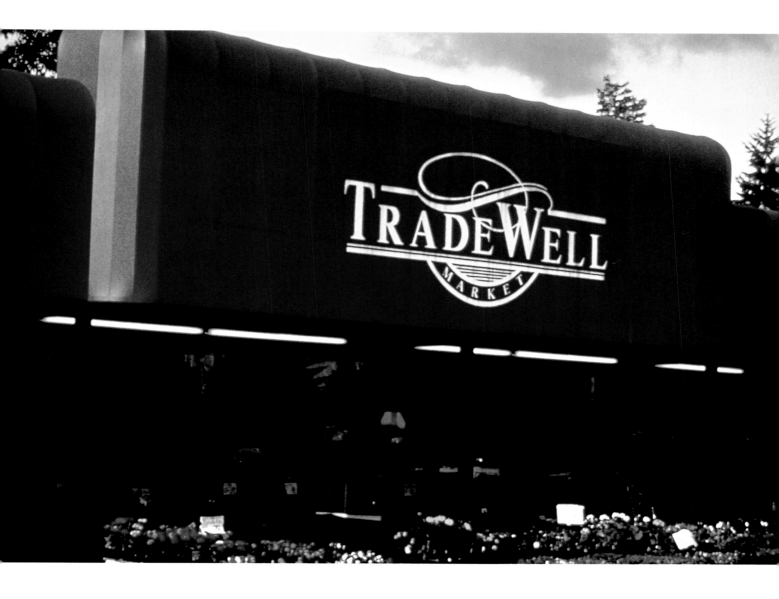

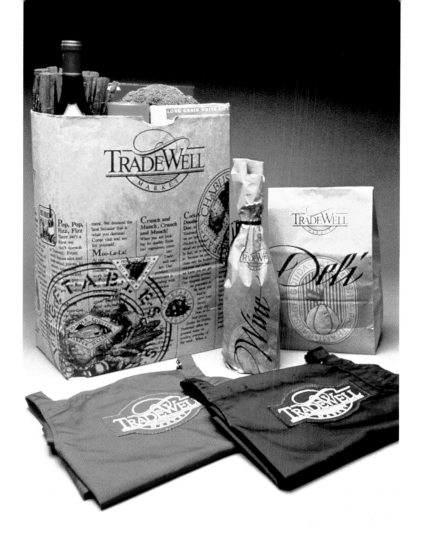

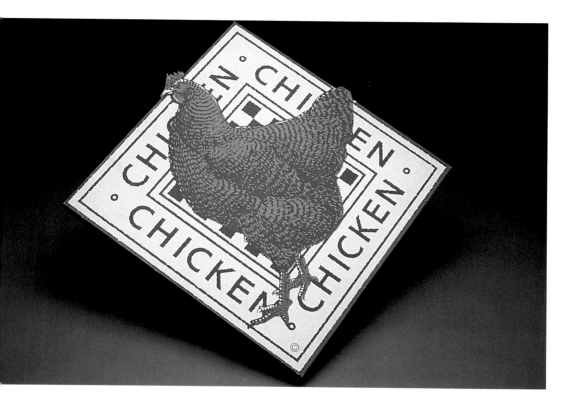

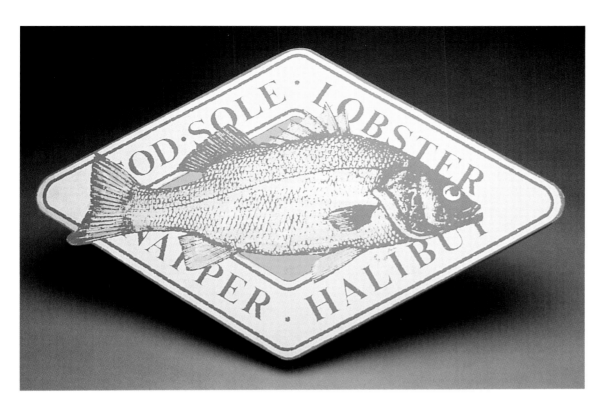

designed by
Todd Malhoit
at
Ford & Earl Associates
Troy, Michigan
for
E-Z Bet

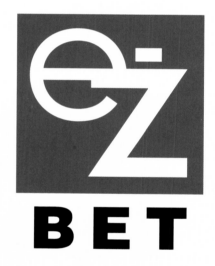

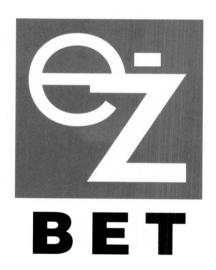

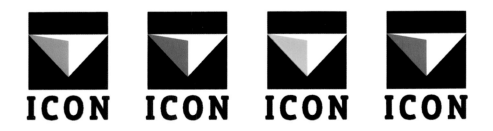

designed by
Icon Graphics Inc.
Rochester, New York
for
Icon Graphics Inc.

designed by
 Mr. Tharp, Jana Heer, Jean Mogannam, & Susan Jaekel
at
 Tharp Did It
 Los Gatos, California
for
 LeBoulanger Bakery Cafes

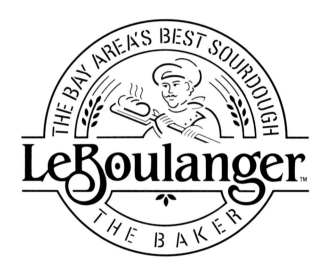

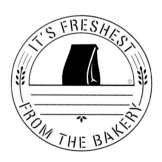

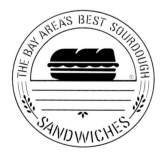

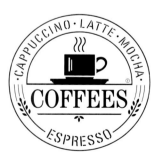

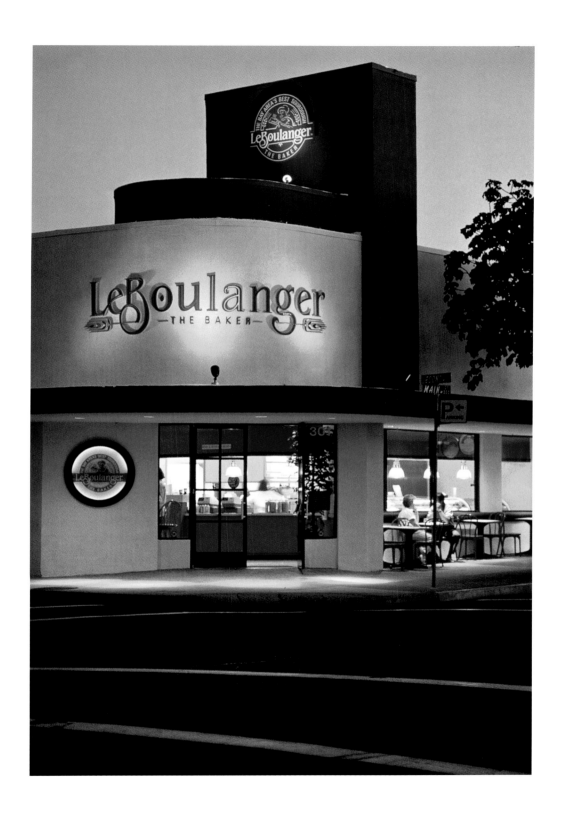

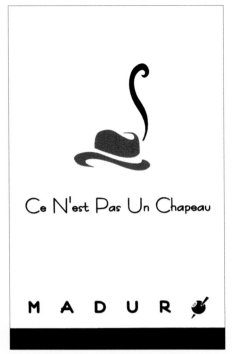

Ce N'est Pas Un Chapeau

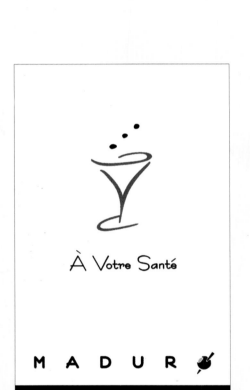

À Votre Santé

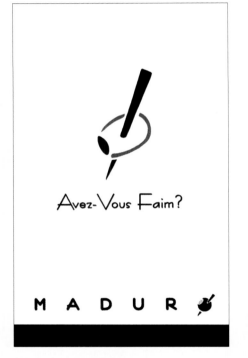

Avez-Vous Faim?

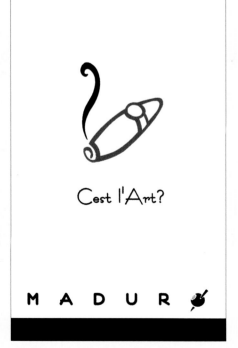

Cest l'Art?

designed by
 Mark Schmitz
at
 Z·D Studios
 Madison, WI
for
 Maduro Cocktail Lounge

designed by
Alan Mickelson
at
Mickelson Design & Associates
Ames, Iowa
for
City of Cedar Rapids

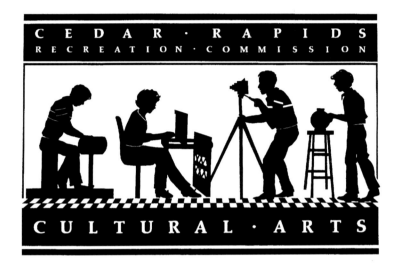

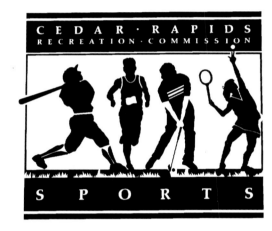

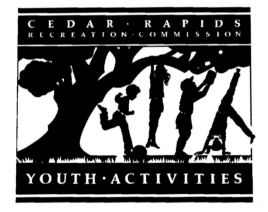

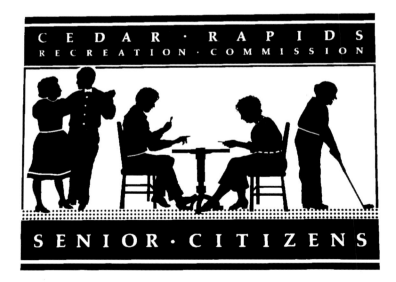

designed by
Arne Ratermanis
at
Lorenz Advertising
San Diego, California
for
Fat Head Brand

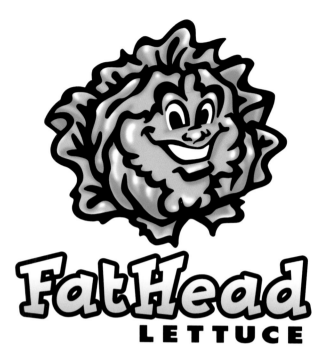

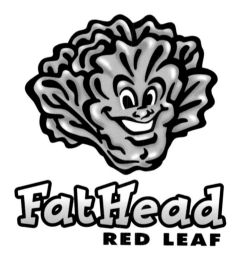

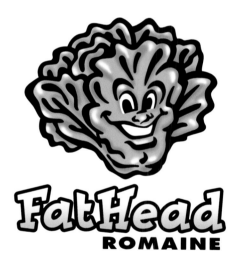

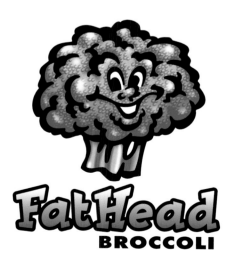

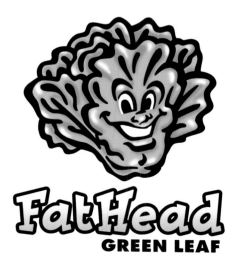

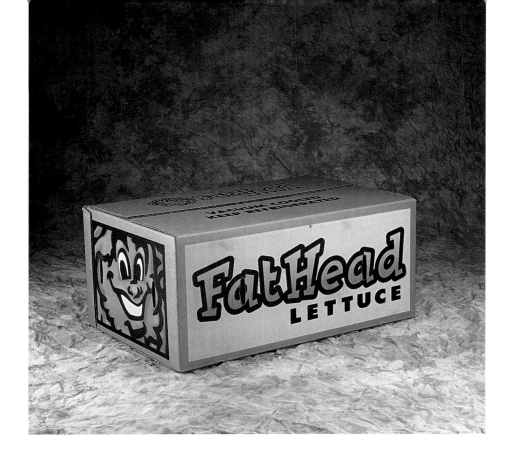

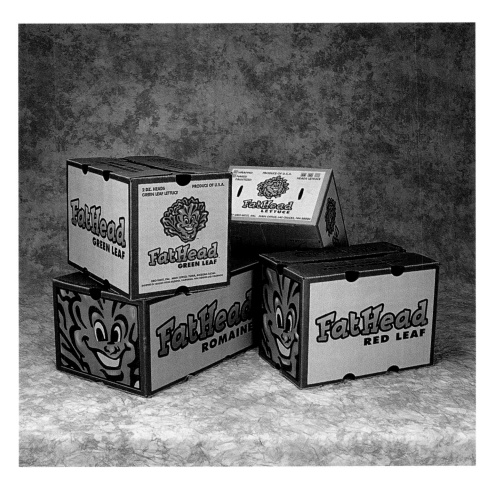

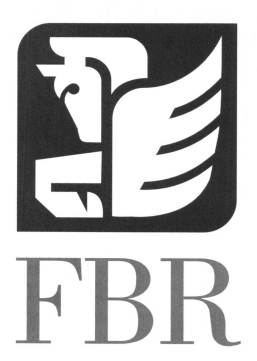

FBR

designed by
 John Cabot Lodge & Denise Sparhawk
at
 Iconixx
 Bethesda, Maryland
for
 Friedman Billings and Ramsey

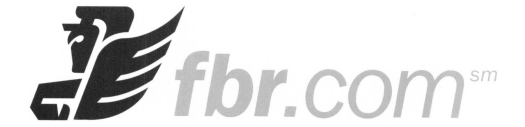

a division of FBR Investment Services, Inc.

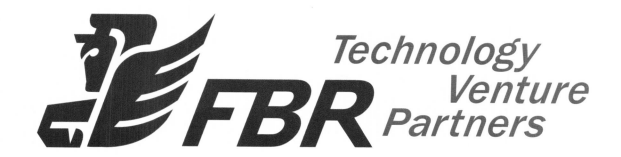

designed by
Donna Bonato Orr & Alvaro Iparraguirre
at
bonatodesign
Berwyn, Pennsylvania
for
S.F.I. (Schratter Foods Inc.)

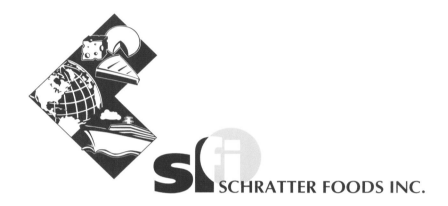

SCHRATTER FOODS INC.

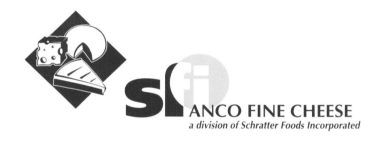

ANCO FINE CHEESE
a division of Schratter Foods Incorporated

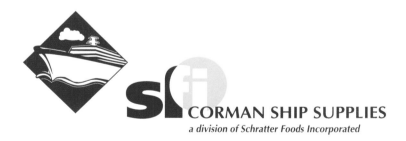

CORMAN SHIP SUPPLIES
a division of Schratter Foods Incorporated

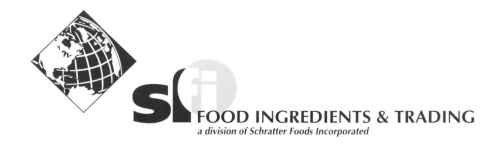

FOOD INGREDIENTS & TRADING
a division of Schratter Foods Incorporated

designed by
 John Sayles
at
 Sayles Graphic Design
 Des Moines, Iowa
for
 Micro Systems

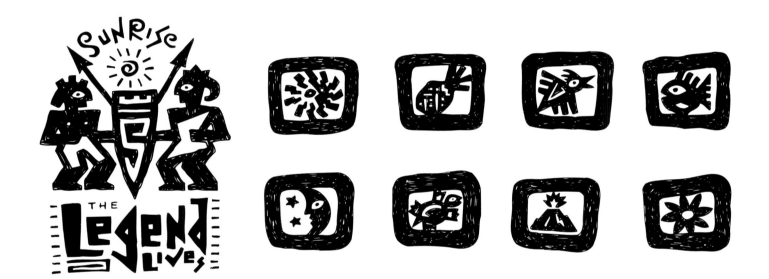

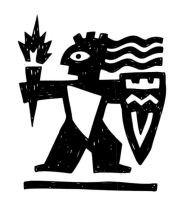

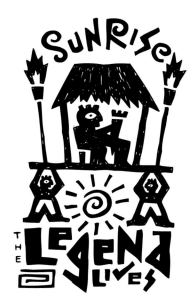

 personify

 personify

designed by
Jack Anderson, Debra McCloskey, & Holly Finlayson
at
Hornall Anderson Design Works
Seattle, Washington
for
Personify

146

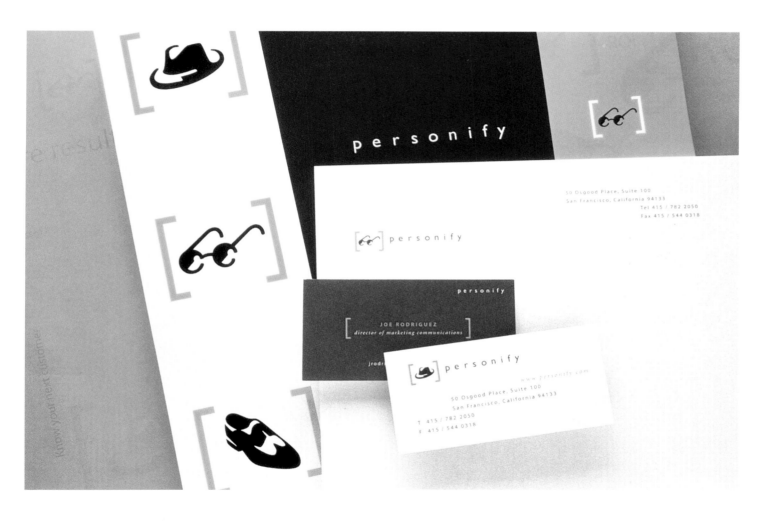

designed by
Jack Anderson & David Bates
at
Hornall Anderson Design Works
Seattle, Washington
for
Alki Bakery & Cafe

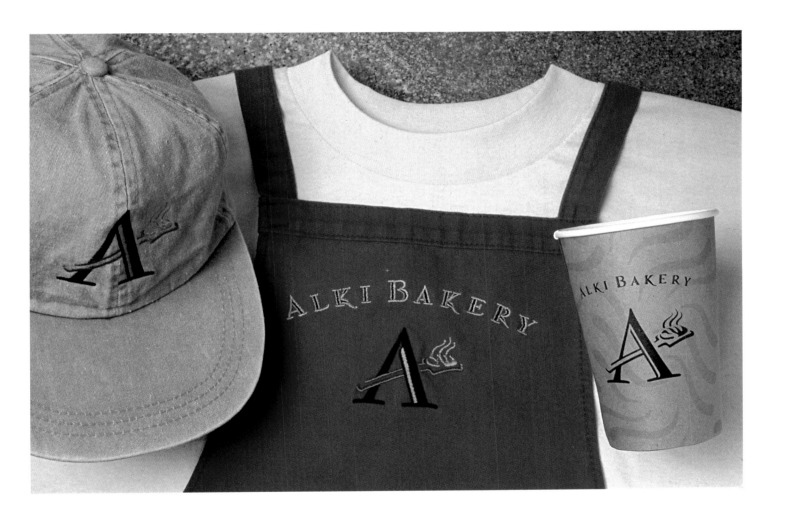

designed by
John Sayles
at
Sayles Graphic Design
Des Moines, Iowa
for
State of Iowa Tourism

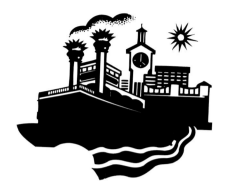

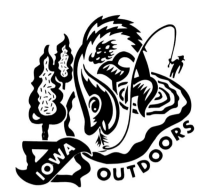

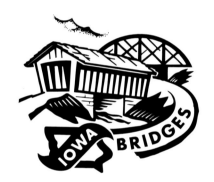

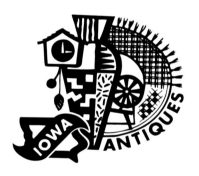

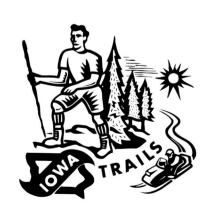

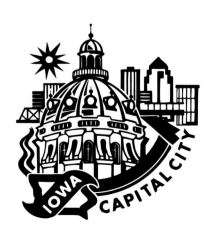

"This airline operates in the South of France and Southern Europe
(Spain, Switzerland and Italy)."

designed by
 Marc-Antoine Herrmann, Marie Laporte,
 Jesper Von Weidling, Per Masden, & Jerome Dam
at
Metzler & Associes
 Paris, France
for
 Air Littoral

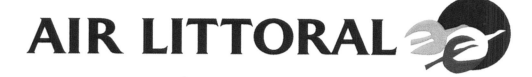

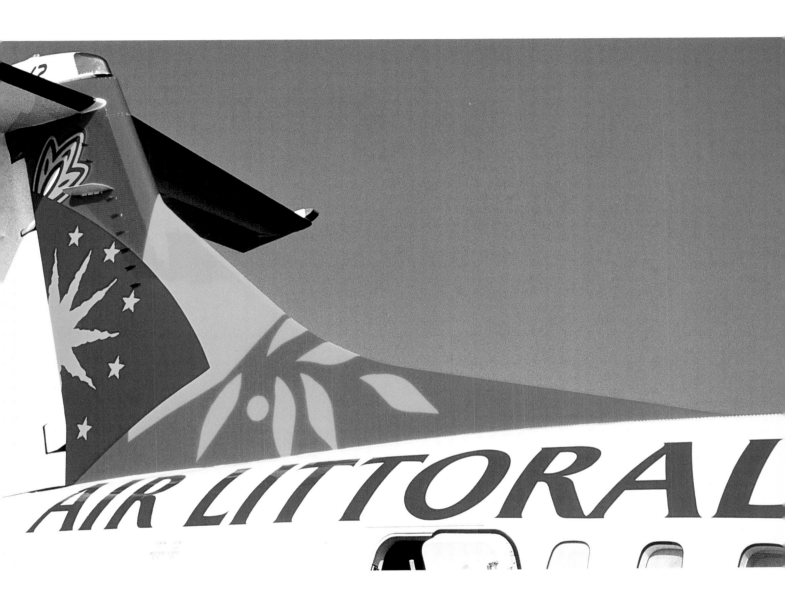

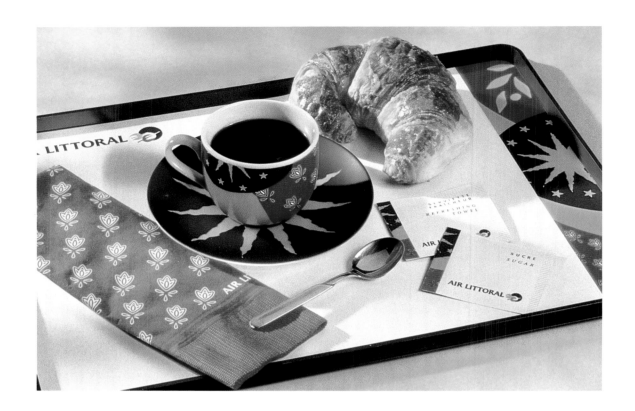

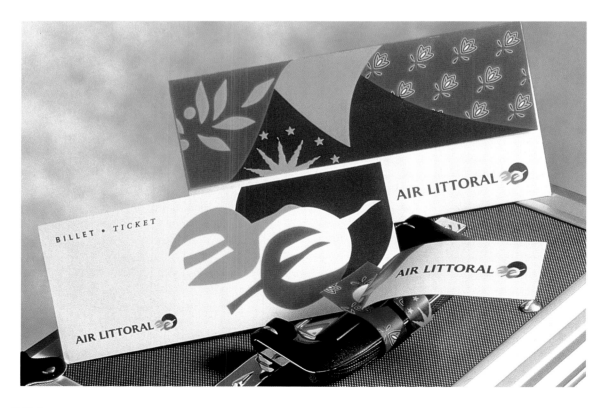

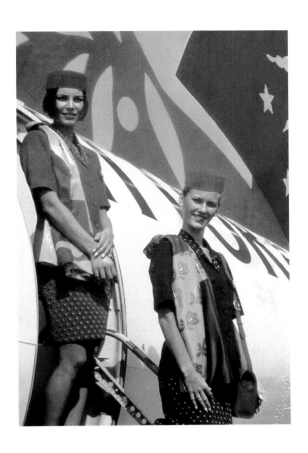

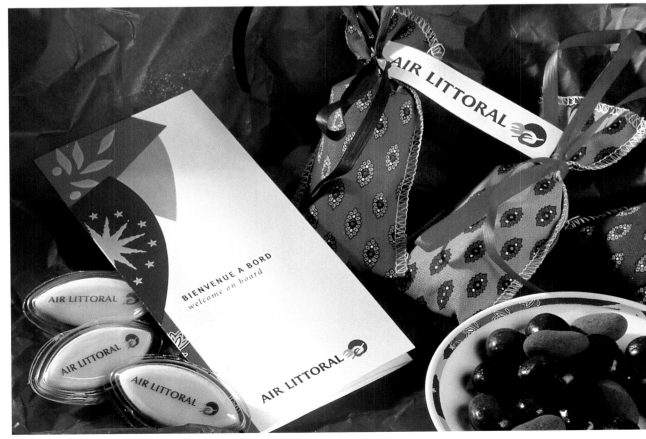

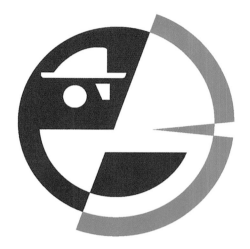

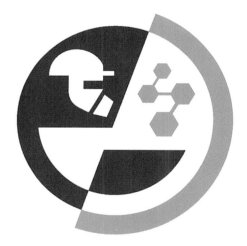

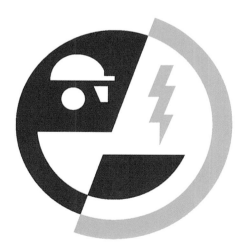

designed by
 David Curtis & Sean McGrath
at
 Curtis Design, LLC
 San Francisco, California
for
 Timec

WorldwideWelding

A **TIMEC** COMPANY

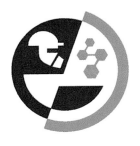

JTCatalyst

A **TIMEC** COMPANY

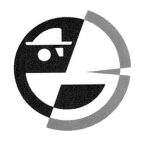

WelltechSafety

A **TIMEC** COMPANY

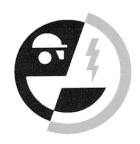

EIUServices

A **TIMEC** COMPANY

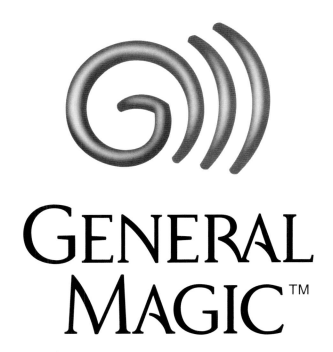

designed by
 Jack Anderson, Jana Nishi, Mary Chin Hutchison,
 Larry Anderson, Michael Brugman, & Denise Weir
at
 Hornall Anderson Design Works
 Seattle, Washington
for
 General Magic

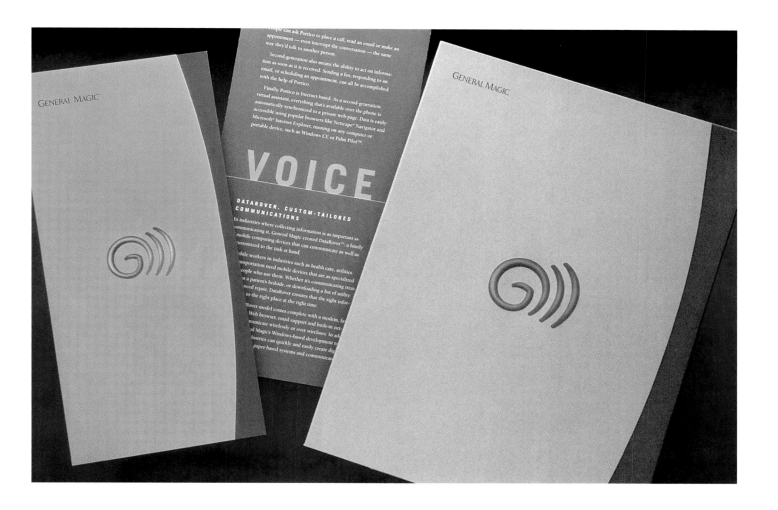

designed by
 John Sayles
at
 Sayles Graphic Design
 Des Moines, Iowa
for
 Sayles Graphic Design

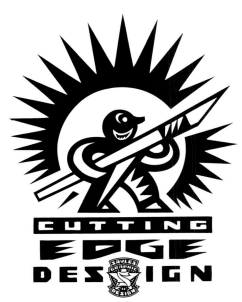

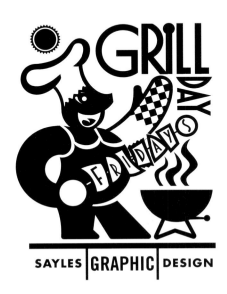

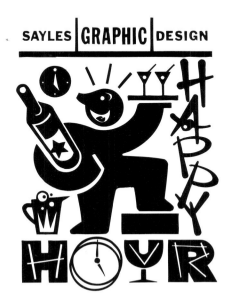

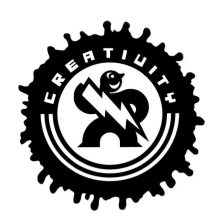

designed by
Mark Schmitz, Heather Holte, & Cindy Neal-Walker
at
Z·D Studios
Madison, Wisconsin
for
Wisconsin Education Association

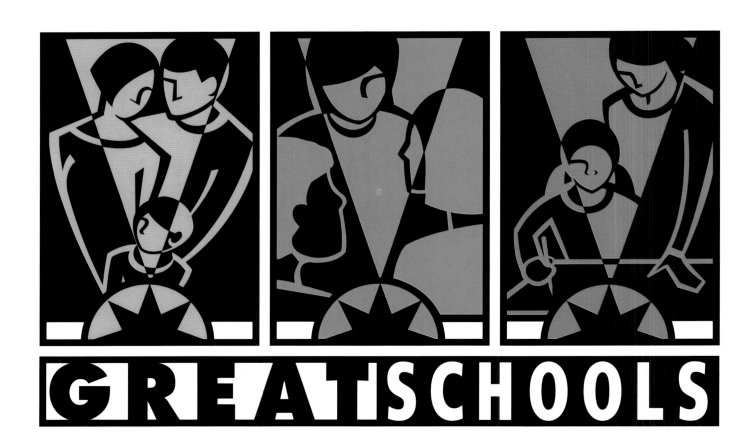

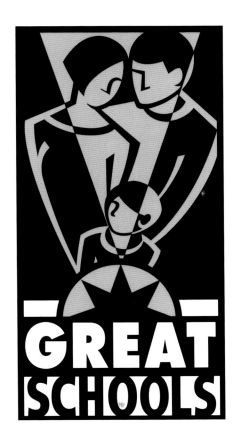

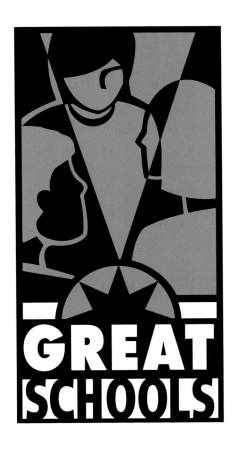

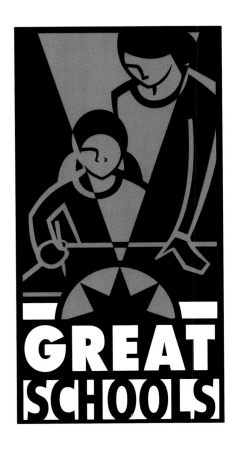

art directed by
Phillips Engelke & Thom McKay
and designed by
Jill Popowich
at
RTKL Associates Inc.
Baltimore, Maryland
for
Belz Enterprises

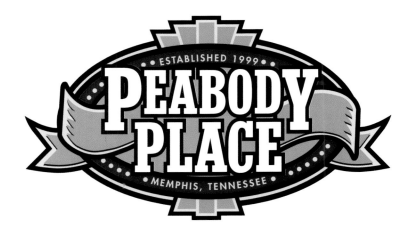

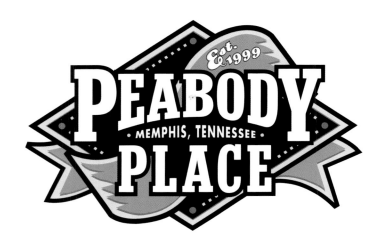

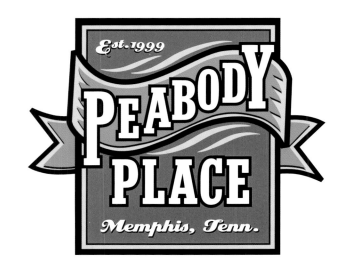

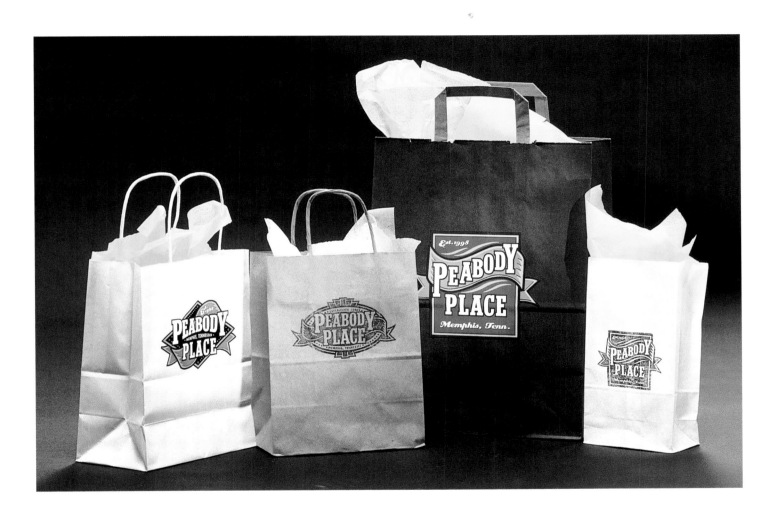

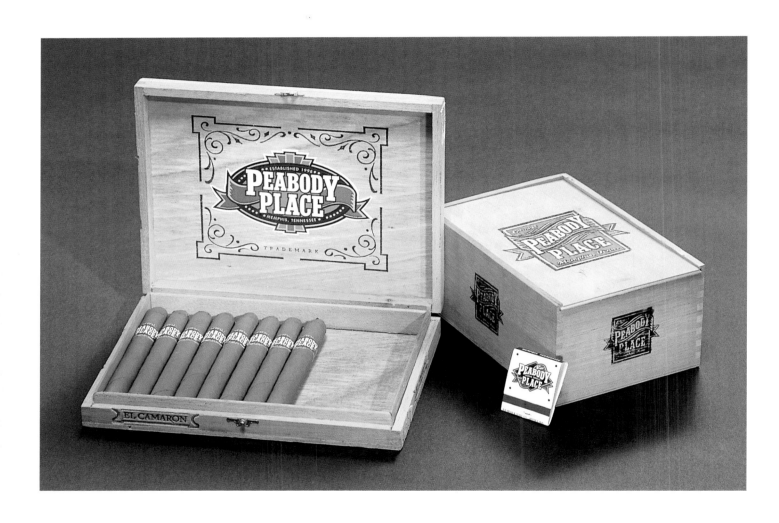

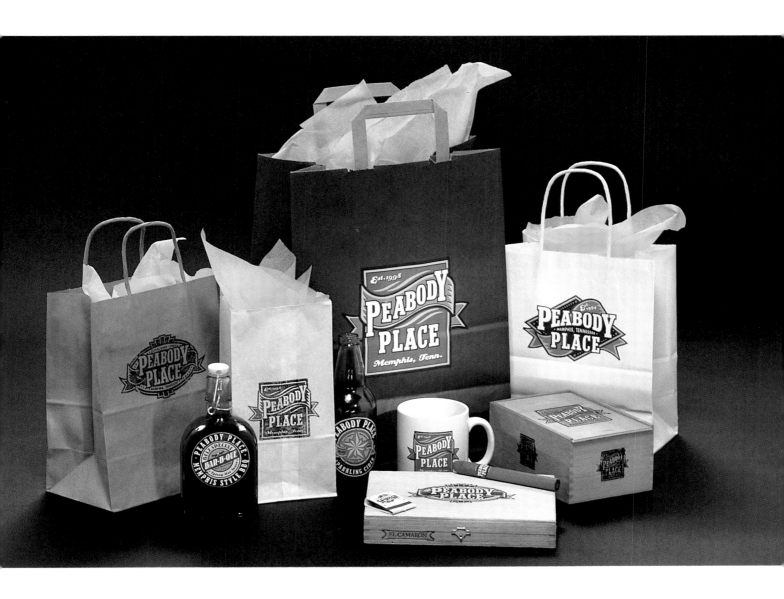

designed by
John Sayles
at
Sayles Graphic Design
Des Moines, Iowa
for
Meredith Corporation

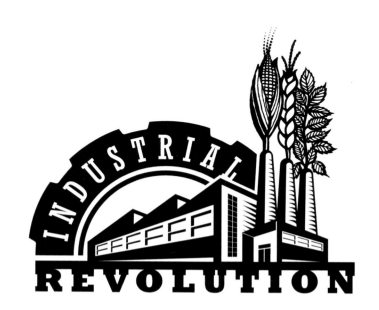

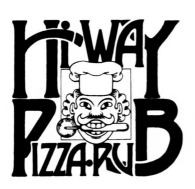

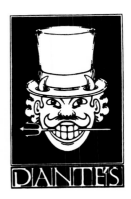

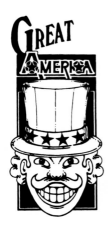
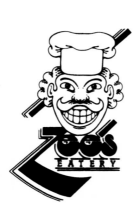
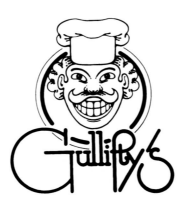
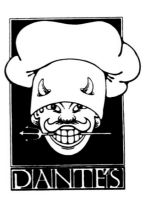

designed by
 Lanny Sommese & Bill Kinser
at
 Sommese Design
 State College, Pennsylvania
for
 Dante's Restaurants Inc.

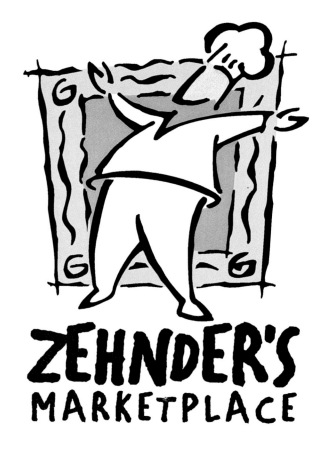

ZEHNDER'S MARKETPLACE

Z·CHEF'S CAFE

ZEHNDER'S
MARKETPLACE

Z·BAKERY

ZEHNDER'S
MARKETPLACE

Z·GIFTS

ZEHNDER'S
MARKETPLACE

Z·JAVA CAFE

ZEHNDER'S
MARKETPLACE

Z·BAKERY

ZEHNDER'S
MARKETPLACE

Z·BAKERY

ZEHNDER'S
MARKETPLACE

designed by
Tony Camilletti & Brian Eastman
at
JGA, Inc.
Southfield, Michigan
for
Zehnder's Marketplace

171

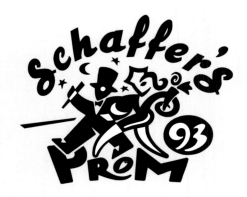

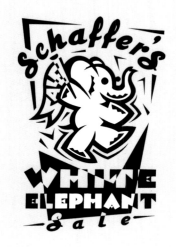

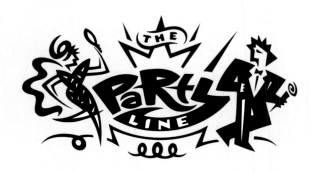

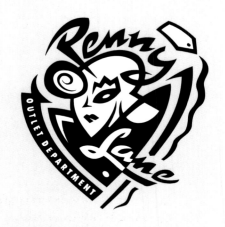

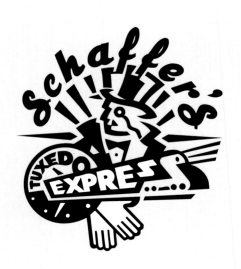

designed by
John Sayles
at
Sayles Graphic Design
Des Moines, Iowa
for
Schaffers Bridal Shop

designed by
Mr. Tharp, Charles Drummond, & Susan Jaekel
at
Strategic Communications
Los Gatos, California
for
TrukkE Winter Sports Boots

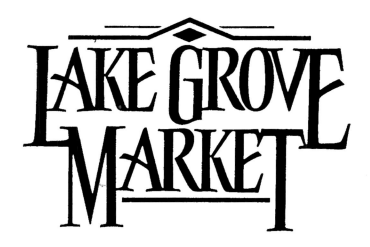

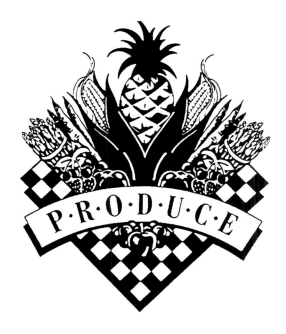

designed by
Jack Anderson & Jani Drewfs
at
Hornall Anderson Design Works
Seattle, Washington
for
Lake Grove Market

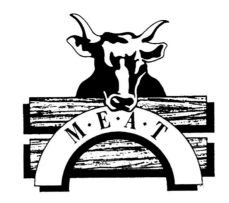

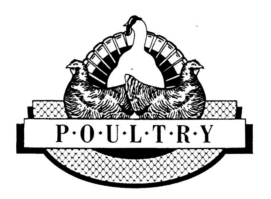

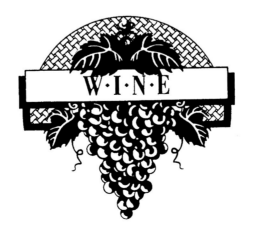

designed by
John Sayles
at
Sayles Graphic Design
Des Moines, Iowa
for
Buena Vista University

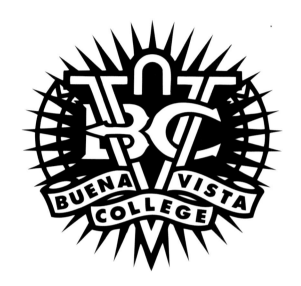

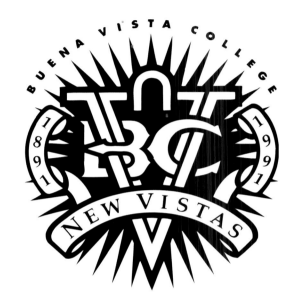

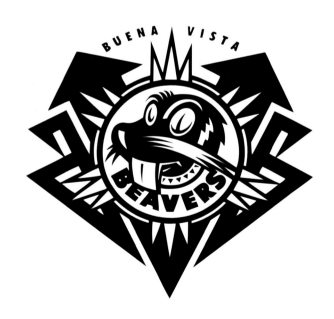

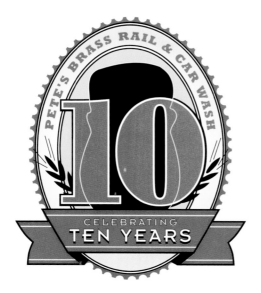

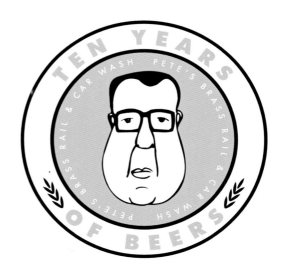

"The client, a 'beer drinking' restaurant, decided to celebrate their ten-year anniversary with four different T-shirts—one released each month prior to the actual anniversary date. Each tee lists one hundred of the four hundred total 'visiting' beers. And, the face appearing in each is a cartoon of the amiable owner."

designed by
 Marcie Carson
at
IE Design
 Studio City, California
for
 Pete's Brass Rail & Car Wash

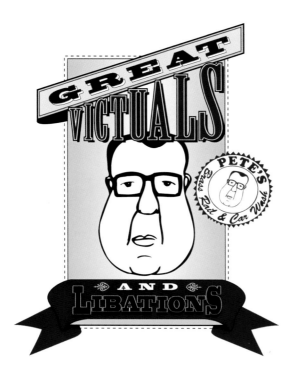

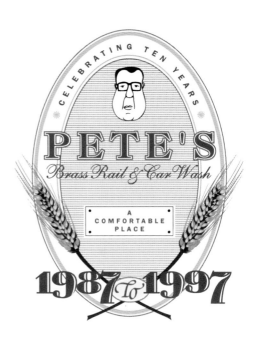

designed by
Jack Anderson, Denise Weir, David Bates, & Lian Ng
at
Hornall Anderson Design Works
Seattle, Washington
for
Windstar Cruises

designed by
 Stephanie West & Tracy Moon
at
 AERIAL
 San Francisco, California
for
 Wedding Network.com

designed by
John Sayles
at
Sayles Graphic Design
Des Moines, Iowa
for
Phil Goode Grocery

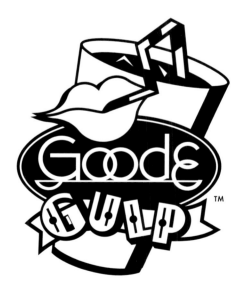

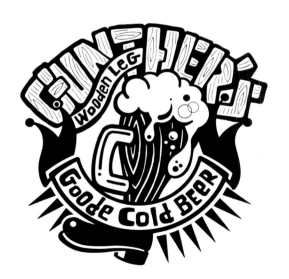

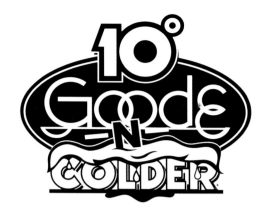

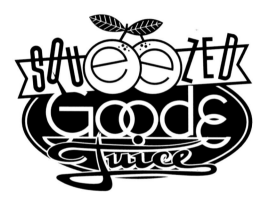

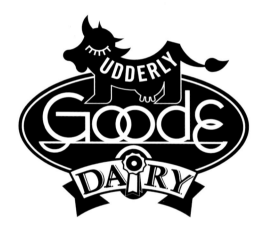

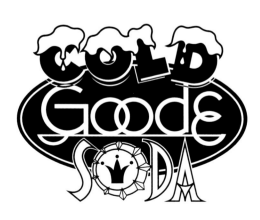

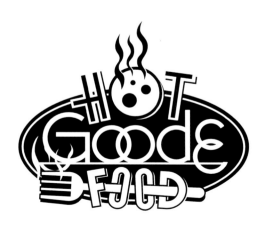